Photographs of a lost way of life, 1930s–1970s

Geoff Charles: Wales and the Borders

IOAN ROBERTS

The publishers wish to acknowledge the support
of the Books Council of Wales

Cover photograph: National Library of Wales
Cover design: Y Lolfa

ISBN: 978-1-912631-19-3

Published and printed in Wales
on paper from well-maintained forests by
Y Lolfa Cyf., Talybont, Ceredigion SY24 5HE
website www.ylolfa.com
e-mail ylolfa@ylolfa.com
tel 01970 832 304
fax 832 782

Contents

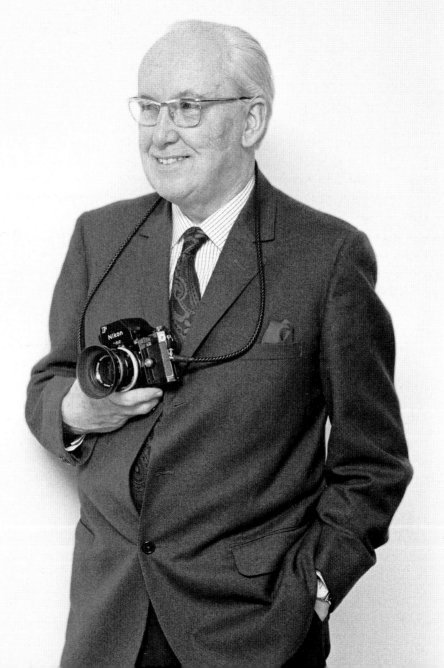

Introduction

I first met Geoff Charles beneath the statue of Lloyd George in Caernarfon on St David's Day 1969. We had been summoned there by Llion Griffiths, editor of *Y Cymro* [The Welshman] newspaper, to cover a rally protesting against the forthcoming Investiture of Prince Charles as Prince of Wales. I had just been appointed to my first job on the paper but was not due to start for another month. Technically, I was still a civil engineer working my notice with Shrewsbury Borough Council, but the short-staffed editor had no reporter available to cover the rally and had asked me to spend my Saturday afternoon helping him out. Geoff, by contrast, had served the paper with distinction for decades and had legendary status as a photojournalist. My apprehension about the career change was not helped by the prospect of teaming up with my new colleague. How would he react to working with this novice?

My fears were soon dispelled. Geoff was friendly and relaxed, ready to offer advice but in no way condescending. Thousands attended the rally, a boisterous and good-natured event despite the tensions engulfing Wales that year. Geoff was a picture of calmness, gliding unobtrusively through the crowd, eyes scanning the scene, camera at the ready, while I took scrambled notes of the speeches.

Over the next six years we shared numerous car journeys throughout the northern counties of Wales in pursuit of stories. We attended other protests, press conferences, election campaigns and eisteddfodau, but were also given free rein to find human interest features about the everyday lives of ordinary people. Some of these involved traditions and lifestyles that were disappearing: slate quarries facing closure, rural schools battling for survival, the changing face of farming. Consciously or otherwise, we were recording history, as Geoff had been doing over many years. Having trained as a journalist and worked as a reporter, he was always aware of the story behind the picture. He had his pet subjects, especially trains, cars and agriculture, but his main asset in his job was an insatiable curiosity about people. Approaching retirement he had lost none of his youthful enthusiasm for the job.

Travelling by car with Geoff was an education. He always had a stock of maps available but these were rarely required. He knew his way everywhere; most towns and hamlets would evoke memories of stories he'd covered and people he'd met.

He was organised, meticulous and disciplined in everything he did. At that time seat belts in cars were new and not yet compulsory, but he would never drive off until we were both belted up. If we approached a gate on a farm lane he would start assessing in advance which way it opened – 'To me', 'From me' – so that he knew exactly where to stop. If I was driving and we were approaching a Give Way sign, he would issue instructions like a batsman contemplating a run – 'stop', 'wait', 'go'.

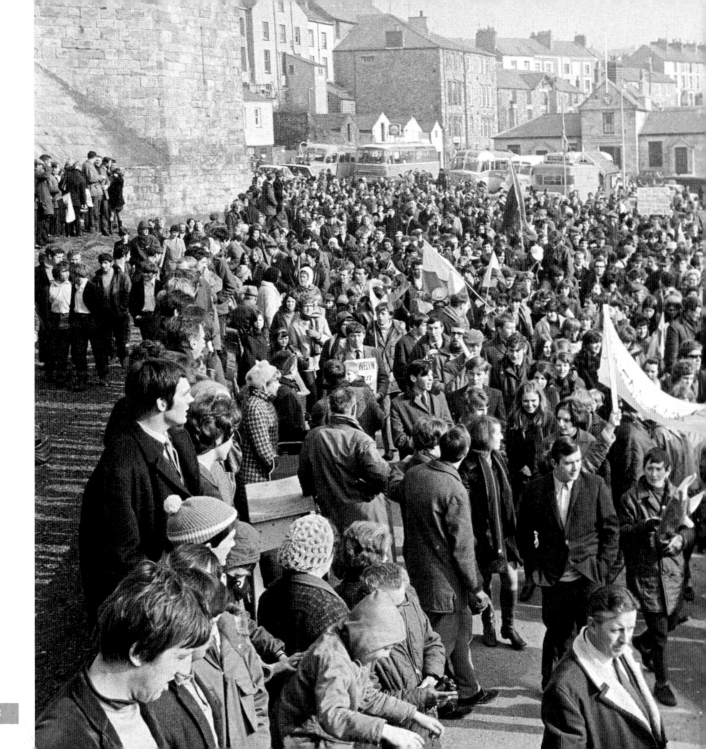

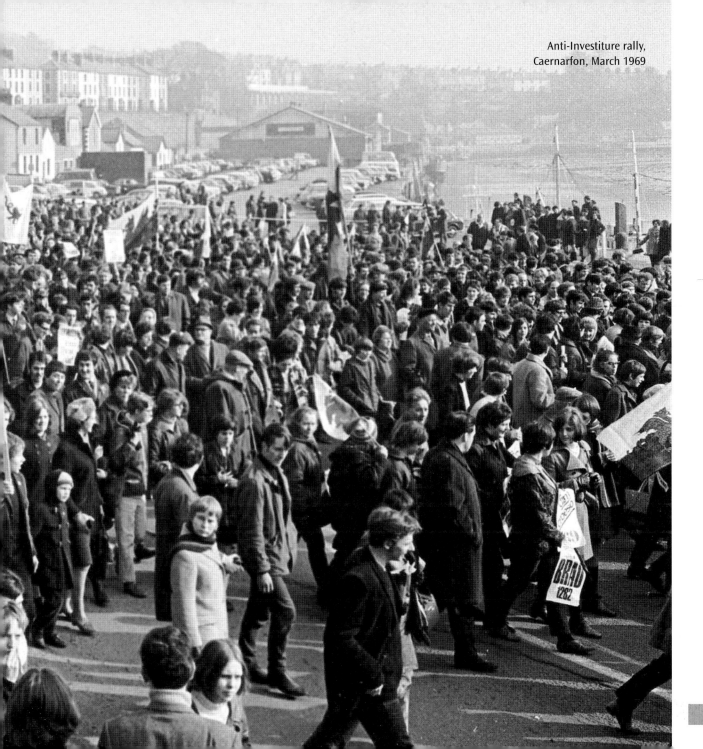

Anti-Investiture rally,
Caernarfon, March 1969

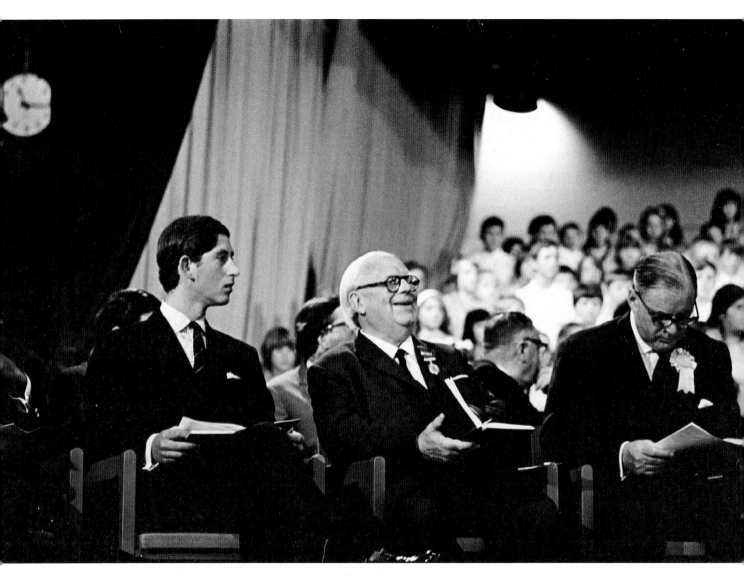

Prince Charles with Archdruid Cynan at the National Eisteddfod, Flint, August 1969

His car, unlike mine, was always tidy and spotlessly clean. There was hardly a cross word between us over the years but he did reprimanded me once for closing the passenger door too forcefully, which he feared could chip the paint. He treated his camera equipment with the same reverence. Every lens, body and accessory occupied its own slot in a foam-lined case and carried a label with the owner's name and address. He always carried a small notebook in his pocket where he took notes in copperplate handwriting for his captions.

Taking good photographs required a lot more technical and visual skills in those days. Autofocus cameras were only introduced towards the end of his career and most cameras did not have built-in exposure meters. Sharp, correctly exposed and well composed images depended entirely on the photographer. All this was second nature to Geoff.

He possessed the equally vital knack of getting on with people and making his subjects feel at ease. If I was to interview somebody, Geoff would sometimes get them to pose for a portrait, taking great care with the lighting and background. He would get me to hold a flashgun connected by a cable to the camera, instructing me where to point it. With a few of these staged images in the can, he would retreat into the background while I did my interview, snatching more frames when the interviewee had forgotten all about the camera. He knew instinctively when to press the shutter to catch a telling mannerism or facial expression. It was often one of those candid shots that made it into print.

He liked to have a plan of action whatever the assignment, but always had an eye for the unexpected. We were once eating lunch in a café near Chirk when a lorry parked outside the window, stacked with cases of French wine. 'Look!' said Geoff, grabbing his camera and dashing outside. He'd spotted a box carrying the label 'Château Calon Ségur' with a heart-shaped logo. In Welsh the words mean 'idle heart' and we envisaged some French village that had witnessed a tragic incident involving some Welsh soldiers in the First World War. We published the picture in *Y Cymro*, asking readers for an explanation, which was not forthcoming. Now, thanks to Google, I know that the name had nothing to do with Wales, but is derived from the old French word 'calon' – boat.

On another occasion we were in Amlwch for an article about a retired ship's captain. Geoff went into a jeweller's shop to ask the way to the captain's house and spotted a young woman repairing clocks and watches. In those days stories about women doing what was regarded as a man's job were commonplace. Geoff was told by the proprietor that she was the only female watchmaker in Wales and we had two articles that day.

I was once invited to Geoff's inner sanctum on the top floor of his home in Bangor that served as his office cum darkroom. As well as the technical area with an enlarger, chemicals, sink and all the paraphernalia required for processing his pictures, there was a corner that resembled a library. On the shelves were thousands of negatives and contact

prints filed in albums and catalogued on index cards. If he needed to access a picture he'd taken decades previously, he could locate it in an instance without the aid of a computer and produce high-quality prints. He told me during that visit in 1970 that it was his intention one day to donate his archive to the National Library of Wales in Aberystwyth.

Little did I think then that in the next century I would have the pleasure of browsing through that unique collection of 120,000 photographs and compile books on Geoff's life and work. Three books in Welsh, *Cymru* [Wales] *Geoff Charles, Cefn Gwlad* [countryside] *Geoff Charles* and *Eisteddfodau Geoff Charles* were published between 2002 and 2007. This book is not an exact translation of any of those but is largely based on the same sources, including interviews with some of Geoff's friends and colleagues who are no longer with us. I relied heavily on taped interviews with Geoff conducted by the National Library and stored at the Screen & Sound Archive in Aberystwyth. I am indebted once again to the staff of Y Lolfa and the National Library for their support, and to the Books Council of Wales for financial assistance.

Brymbo

Geoff Charles is remembered primarily as a chronicler of life in rural, Welsh-speaking Wales. Most of the best-known images in his photographic collection appeared first in the Welsh-language *Y Cymro*, many others in *Country Quest* magazine and the farming press. Yet his formative years were spent in an environment that was not particularly Welsh or rural. The family had lived for generations in Brymbo close to Offa's Dyke in the north-eastern corner of Wales, a village dominated by giant steelworks and surrounded by small collieries. His early memories of strikes, soup kitchens and industrial accidents had more in common with the mining valleys of south Wales than the rural north and west. Although both parents were fluent in Welsh and attended a Welsh chapel, Geoff recalled that they only spoke the language at home to the cat and the dog, or to each other when they didn't want the children to understand. The transition from a predominantly English-speaking child of the Borders to National Eisteddfod stalwart and robed member of the Gorsedd of Bards is an interesting strand in his life story.

Born in January 1909, Geoff was the eldest of the three children of John Charles, manager of the Brymbo Water Company, and Jane Elizabeth Charles, known within the family as Lily, a former nurse who gave up her career to look after her children. Geoff's brother Hugh was born in 1910 and sister Margaret in 1916. His father was one of the ten children of Thomas and Mary Charles whose family had lived in the same house, known as the Old Vicarage, since the 1860s. During Geoff's early childhood the family moved to live in the Old Vicarage on the death of his grandparents.

In 1997 Geoff, in collaboration with his brother Hugh, published an autobiographical account of his early childhood in a book called *The Golden Age of Brymbo Steam*. In this he says that his father John had been regarded as a confirmed bachelor until 'a young and pretty Queen's Nurse came to Brymbo to work with another one who was already there'. Queen's Nurses, a charity originally financed by Queen Victoria's Jubilee Fund, provided medical care for those who needed it in their own homes, and was the beginning of organised district nursing. 'Lily' Reade and her colleague lived in a cottage especially built for the Queen's Nurses in Brymbo. Lily's stay in the cottage was relatively short. On their marriage she and John moved to a house called Bryn Awel where Geoff was born.

In contrast to her husband with his deep Brymbo roots, Lily had family connections over much of Wales. Her father had been a house painter in Pwllheli and worked for a while in Lymm, Cheshire. When her parents were struck by ill health, Lily was put in the care of her grandparents in Caernarfonshire. Her grandfather worked for the London and North Western Railway in Bangor

Geoff's father, John Charles

is no evidence that Geoff ever met his uncle or that Thomas's success influenced his choice of career, but Geoff was well aware of his existence. Born in Brymbo in 1866, Thomas emigrated in the late 1880s to Scranton, Pennsylvania, a bustling industrial centre based, like Brymbo, on coal, iron and steel. Scranton was once the most Welsh city in America, with a lively cultural, social and religious life including eisteddfodau, St David's Day celebrations and their own newspapers in both languages. There are conflicting accounts of whether Thomas had any journalistic experience at home before he emigrated, but in Scranton he started in a junior post with the *Cambrian* newspaper and climbed rapidly through the ranks. In 1907 he became a founder and editor of the *Druid*, later renamed *The Welsh-American*. He moved to Pittsburgh when the paper was bought by a syndicate from that city in 1912, but died suddenly from pneumonia in 1916 at the age of fifty. Through his paper he had championed many causes back home in Wales, raising money for the families of miners killed in the Senghennydd Colliery disaster and supporting Welsh soldiers in the First World War. He never lost his allegiance to Wales or his love of writing. In 1912 he published a novel, *Dear Old Wales: A Patriotic Love Story*. His obituary in the *Cambrian* described him as 'a talented Welshman, big hearted and always doing something good and great for his race. He was a loveable man and one of the real popular men of his day.'

Thomas Charles had maintained contact with his family all his life. Geoff recalled that in the

and at nearby Treborth. When the parents' health improved they wanted the little girl back but her grandmother refused to part with her. After the grandparents died Lily was placed in the care of an aunt, who had married a doctor and moved to Mountain Ash in the Glamorgan coalfield. Geoff was reacquainted with his south Wales relatives early in his journalistic career when he lodged with some of them while working on newspapers in Cardiff and the Valleys.

There was no tradition of journalism in the family, with the notable exception of Thomas Owen Charles, John Charles's eldest brother, who became a leading figure in the Welsh life of America. There

Geoff's mother, Jane Elizabeth Charles

family home in Brymbo there was a chair known as 'Nain Charles's steamer chair'. Geoff's grandmother had brought the chair home from America on a steamship after going on a voyage to America to visit her son. After Uncle Thomas's death his widow and two daughters visited Wales, but Geoff over the years had 'regrettably' lost touch with his American cousins.

Brymbo suffered hardship in the depressions of the 1920s and 1930s and, although the Charles family lived in relative comfort, they were affected by the poverty around them. One of Geoff's aunts ran a

series of soup kitchens for strikers' families during the 1921 miners' strike. During the Brymbo Steelworks shutdown ten years later, an unemployed girl offered to work for the family as a maid for two pots of dripping a week, but Mrs Charles insisted on paying her a proper wage.

The family home was adjacent to a railway, and for Geoff and his brother trains became a lifelong passion. Almost every childhood tale in *The Golden Age of Brymbo Steam* is in some way involved with the railway:

> Railways and trains touched our young lives at every point and were our constant companions… They woke us in the morning, took us to school and brought us home again, gave us a real-life hobby far better than playing with any toys, and lulled us to sleep at night.

When the National Eisteddfod was held in Mold in 1923, Geoff was less interested in the festival itself than in a memorable railway journey that came in its wake. Train schedules in the area had to be revamped to provide special services for eisteddfod visitors. A driver called Mr Clark, a family friend, was rescheduled to drive a train carrying lime from Minera Quarry to Brymbo Steelworks. Geoff was allowed to travel on the footplate, assisting the fireman. It would never have crossed his young mind that the National Eisteddfod would become a central part of his life for fifty years.

Although both parents were fluent Welsh speakers, English was the main language of the home.

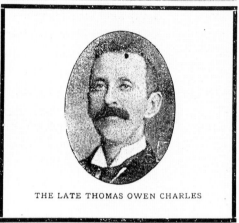

THE WELSH-AMERICAN

FORMERLY "THE DRUID"

FOUNDED 1907 PITTSBURGH, PA.

VOL. IX. NO. 44. PITTSBURGH, PA., OCTOBER, 15, 1916. ONE DOLLAR A YEAR IN ADVANC

THOMAS OWEN CHARLES CALLED BY DEATH

Editor of the Welsh-American Succumbs to an Attack of Septic Pneumonia.

DEMISE CAUSES GREAT GRIEF

It is with poignant and indescribable grief that we record the passing of the soul of Thomas Owen Charles, editor of the Welsh-American, through the portals of death into its heritage of everlasting life, after an earthly pilgrimage of fifty years. Mr. Charles was in his accustomed health until within a few days of his demise, and as his illness was known to but a few, the news of his sudden death was a shock to a host of friends. When the sad tidings reaches the readers of the Welsh-American, a journal with which his name is inseparably associated, the news of his departure will cause universal grief among thousands of Cambro-Americans, for his name was a household word among his compatriots in every state of the Union.

Death is always an unwelcome visitor and especially so when a beloved

THE LATE THOMAS OWEN CHARLES

city, and later the name of the paper was changed to "The Welsh-American." A year and a half ago, Mr.

resented friends from far and near, from Pennsylvania, Ohio and West Virginia and the floral offerings

BUDGET OF NEWS FROM NEW CASTLE

Proceeds of Welsh Day Donated to Relieve Distress in Dear Old Wales.

A REUNION AGAIN NEXT YEAR

New Castle, Pa.—The Welsh Day reunion committee met in the Emmanuel school room on Saturday night, September 30. In addition to the local members of the committee. George Morris, of Farrell, and David J. Jones, William F. Jones and John R. Rogers, of Ellwood City, were present. Report of the auditors was read by Benjamin Powell, showing a balance on hand of $45.34, and it was decided to send this sum to the Hon. D. Lloyd George, to alleviate the distress in Wales caused by the war. Excellent spirit was in evidence, and it was resolved to hold another reunion next year.

The Rev. George Richards, who recently returned from a visit to Wales, was present at the meeting, and on request responded with a brief talk on his jaunt to his native land. He said the Welsh and the English have unbounded faith in their ultimate

CYMRIC ACTIVITIES IN PHILADELPHI

Charles Evans Hughes, the Republic Nominee for President, Tendered a Rousing Ovation.

A VISITOR FROM AUSTRALI

By David Chappell.

Philadelphia, Pa., October 13.—T Hon. Charles Evans Hughes, the publican nominee for president, had grand ovation in this city Mond evening, October 9, when he spoke the Metropolitan Opera House, und the auspices of the Union Leag Mr. Hughes has not the most me dious voice in the world, but he i master as a calm reasoner, and c vinces his hearers as being since and resolute, and a man to whom rich and poor may intrust their fairs. If his popularity is to be me ured by the throngs who wanted hear him, thousands of whom failed gain admission, he is in the most p ular candidate in the field today. us hope that this grand scion of Welsh is elected.

The Hon. R. B. Rees, M. P., of M bourne, Australia, was an interest visitor in our city last week. Rees, who has spent thirty years his life in Australia, is a native Neath, South Wales, and in his talk

Tribute to Thomas Owen Charles, Geoff's uncle, in *The Welsh-American*, the newspaper he had founded

The English border was less than a mile away, and from a hill overlooking the house the dominant view was to the east, in an arc extending from Liverpool and Chester on the left to Shrewsbury on the right. English was the language of the primary school in Brymbo, although there was a bust in the hall of Sir O.M. Edwards who, as Chief Inspector of Schools for Wales, pioneered the teaching of Welsh in schools in its own country. The only concession to the language that Geoff remembered from Brymbo school was being taught a couple of Welsh songs by a young teacher called Miss Williams.

The one place in Brymbo where Welsh was the dominant language was Bethel, the Wesleyan chapel where the Charles family were regular worshippers. The chapel could hold five hundred worshippers

and, in an area with a strong musical tradition, it was always filled to capacity for the annual Good Friday concert. John Charles, like his own father, was a Sunday school teacher; 'fire and brimstone' preachers were held in high esteem and many young men trained for the ministry as an escape route from the coalmines and the steelworks. As a boy Geoff was a reluctant attendee and found the strict Nonconformist Sabbath observation 'almost suffocating'. But he conceded in his autobiography that 'Bethel shaped my young ideas and built into my life some standards that no longer seem to apply'.

Apart from the boyhood dreams of becoming a train driver or racing motorist, his only serious ambition was to be a writer. He enjoyed writing essays in the primary school and remembered in detail how an inspirational young teacher used to correct his spelling. His mother was an avid reader; there was always an abundance of books in the house and she instilled in him a love of reading.

At Grove Park County School in Wrexham he was persuaded to study French rather than Welsh, a decision that he always regretted. But he was grateful to an English teacher called Bob Wright who steered him towards a career in journalism. He told Geoff that he had a gift for writing and persuaded him to apply for a scholarship to study journalism at King's College, London. This was a two-year diploma course, the only university course in journalism in Britain at the time. Geoff's autobiography does not give much information about the course. It contains more detail about his train journey to London at the start of his studies than what he encountered when he got there. The train, known as the 'Zulu', left Wrexham at 12.42 p.m., arrived in Birmingham at 2.44 and got to Paddington at 5.29.

Reporter

The usual route to a career in journalism at that time was through an apprenticeship on a newspaper. The King's College course made sure that their students did not miss out on the practical side by providing them with work experience on Fleet Street newspapers. Geoff did a course in sub-editing on the *Daily Mirror*, and observed *Daily Express* and *Daily Herald* journalists at work. During his summer vacation he worked on the *Warrington Express* in Lancashire, lodging with an aunt who lived in the area.

Having completed his two-year course with a first-class honours diploma, he worked in Cardiff as a reporter on the now-defunct *South Wales Evening Express* and its sister paper, the *Western Mail*. This pleased his mother, who had done her nurse's training in Cardiff and had relatives in the Cynon Valley. Recalling his time in south Wales Geoff said that his 'specialities' included reporting on inquests, dirt-track motorbike racing, and dog racing at Cardiff's Sloper Road stadium. He remembered, in particular, a legendary Irish greyhound called Mick the Miller who broke the world record when he won the Welsh Greyhound Derby in Cardiff.

Around the same period he spent some time working on the *Aberdare and Mountain Ash Express*, staying with his mother's relatives opposite the Deep Dyffryn Colliery. It was a time of industrial strife, with the Labour Party in the ascendancy throughout the Valleys. Geoff spent much of his time covering court cases and local council meetings. He told Beti George, on her Radio Cymru programme *Beti a'i Phobol* in 1984, that he encountered some antipathy in this period from fellow journalists who had gone through the mill on local newspapers and were suspicious of 'privileged' colleagues with their university education. He also missed the company of his student pals who were still based in the London area. When he saw an advert for a reporter on the *Surrey Advertiser* in the early 1930s he decided to apply, and found himself working and living in Guildford.

Any inverted snobbery he had experienced in the Cynon Valley was soon forgotten when he lived in affluent Surrey. 'After working in the Valleys I found Guildford to be an extremely snobbish place,' he told Beti George. 'Although I made many friends there I was never happy in the area.' An escape route offered itself when a letter arrived from a Wrexham friend called Enoch Moss, an ex-collier who had become a journalist. He told Geoff that he was part of a small group of friends who were about to set up a local newspaper with a socialist outlook. He asked Geoff if he would like to join them in the venture.

Before he could reply to the invitation, Geoff was involved in an accident that clinched his decision to come home to Wales. At that time he owned an open-top Fiat car which refused to start one frosty morning. Geoff had to 'crank' the engine with a starting handle, a familiar enough experience with vehicles of that era. Suddenly, the engine gave an almighty 'kick', the handle came out of its socket, striking him on the head and knocking

SEPTEMBER 22nd, 1934 ONE PENNY

Wrexham STAR

— SPECIAL EDITION —

SATURDAY SECOND EDITION

Terrible Wrexham Colliery Disaster

OVER 200 MEN ENTOMBED

Eleven Already Brought Up Dead From Dennis Seam

SEVEN DASH FOR LIBERTY AND ESCAPE
HARASSING PITHEAD SCENES

A TERRIBLE disaster occurred at about 1-40 this morning at the Gresford Colliery when 240 men were entombed.

Up to 9-30 this morning 11 men (writes a Star Special Representative) had been brought up dead, and as I stood there watching the procession of stretchers with their tragic burdens there were harassing scenes at the pit-head.

Crowds of relatives were standing in the pouring rain, drenched after miles of walking and waiting, and some of them knowing in their hearts that they were waiting in vain.

SEVEN MEN DASH TO LIBERTY

There was a ray of hope when the news spread that seven men had escaped the holocaust; their dash for safety was repaid with their lives.

But when I spoke to rescue men who had been toiling for hours, they said that the position was very bad, and apparently there cannot be much hope for the lives of the 240 odd men who are still entombed below the surface.

All the neighbouring collieries have rushed rescue parties to the pit, and as I stood at the pit head I saw lorry loads of stone dust and fire extinguishers being hurried to the pit-head.

Apparently though there has been no official statement as yet, the disaster occurred at about 1 a.m.

TREMENDOUS EXPLOSION

The use of stone-dust leads to the theory that there has been a tremendous explosion. I was told that at 1 a.m. the men on the surface suddenly saw that no more coal was being wound. The question ran round, "What's the matter."

Everyone thought that no coal was available at the time, and little notice was taken until the delay became serious.

Then a message was sent to the other shaft nearby, and then came the ominous reply "there is something wrong below. The pit is full of dust."

Immediately steps were taken; ambulance and rescue stations telephoned, and other collieries asked to stand by. Everything that could possibly be done was done.

When I got to the pit shortly after six all the roads leading to the colliery were thronged with people oppressed with the knowledge of a terrible disaster.

All the roads in the colliery leading to the pit head were crowded, and police even were controlling the crowds. Women whispered, white-faced, red-eyed; tried tearfully to comfort each other; I knew then the terror and tragedy that is the lot of every collier's wife. The spectre that looms over all their homes had been only too suddenly and terribly turned into a tragedy. Below their feet hundreds of feet down were their lovers, husbands, children. As men came up from the pit eager hands clutched at them, eager questions asked; a look at their faces was enough.

BOY LEADS TO LIBERTY

Then the rumour spread that some had escaped: of how one boy led the way to life and liberty,

shouting to his mates to follow him as he did so. Immediately the explosion occurred the boy, who is named Samuels, shouted, "Come on lads," and dashed through the flames and dust to make his way to the foot of the shaft. Only six followed him and all seven were helped to safety by the helpers who had hurried down.

A remarkable thing is that these men are all, to use the words of a rescuer, "as right as rain." Apparently they had escaped serious injury.

The tragedy of the story is intensified by the boy's statement that when he dashed out other men failed by seconds to follow his lead.

As has already been stated no official information is available.

But the fact remains that 240 men are down the pit and all the ambulances are waiting ready but empty. So far apparently there have only been a few bodies recovered, the number is put at eleven.

Rescue parties from all the local collieries are standing by if there be anything can do.

The bodies are for the time being lying in the mortuary at the colliery and there is little the doctors can do unless more men are brought up alive.

NAMES OF DEAD OVERLEAF

Front page of the special edition of the *Wrexham Star*

Furnace workers,
Brymbo steelworks

him unconscious. He was left lying on the freezing pavement for some hours, which led to pneumonia, pleurisy and eventually tuberculosis. His parents went to fetch him in their car and drove him to a specialist TB hospital called Meadowslea at Penyffordd between Wrexham and Chester.

'The very name TB caused horror, and being sent to Penyffordd was almost equivalent to a death sentence,' Geoff said. 'Everyone thought you'd be coming out in a box.'

After a few months of careful nursing with complete rest and good food, he was deemed fit to return to the family home in Brymbo. He followed his parents' advice to take a year off work and spent some of that time helping his father by driving Brymbo Water Company workers around various reservoirs and depots.

By 1933 he felt healthy enough to return to journalism, but had no desire to go back to Surrey. Instead, he contacted his friends who by then had launched their *Wrexham Star* newspaper. It was published on a shoestring by a small printing company called Fletcher and Westall in an old chapel in Wrexham, and Geoff was recruited to join an editorial staff of three. It was a set-up where everybody had to pitch in to do whatever task was required. The *Star* was embroiled in a commercial war against its much bigger and more established rival, the *Wrexham Leader*. The *Star* had set its cover price at one penny, half the cost of the *Leader* which was run by Rowland Thomas, a formidable figure who would later play an important part in Geoff's career. Thomas responded to the undercutting by

using his influence to persuade newsagents in the area to blackball the *Star* and refuse to sell it. The *Star* overcame that hurdle by recruiting unemployed people to sell the paper directly to the public on street corners. In the Great Depression of the 1930s, with Brymbo Steelworks on a long shutdown, there was no shortage of vendors. After working all night on Thursdays putting the *Star* to bed, Geoff would be up and about on Friday driving his car around the villages delivering copies of the paper to the sellers, many of them steelworkers that he knew.

He never forgot the eerie silence around Brymbo with the giant steelworks idle. 'My brother, my sister and I couldn't sleep at night because the place was so quiet. We had become familiar with every friendly sound coming from the works. Now it was like the grave,' he said. But he also remembered fine summers and all the self-help activity that sustained the communities. One man started a jazz band. Women made dresses. Craft centres were set up in any available building and tools provided for repairing shoes and other tasks. Young unemployed people would congregate on a bank in Brymbo known as Top yr Ochor for a sing-song.

While watching a group of these singers, a village policeman told Geoff that he was eager to buy a camera. Geoff told him that he was thinking along the same lines himself. Adding photography to his armoury would help him survive if he ventured into the freelance world. That was the first suggestion that he was contemplating a change of direction in his career. But it was as a reporter on the *Wrexham Star* that he faced what was probably the biggest story of his life.

The Gresford Disaster

Geoff Charles used to describe himself as a 'lucky' photojournalist. On many occasions he happened to be in the right place at the right time to capture a story. Luck is not a commodity that anyone would normally associate with one of the worst tragedies in the history of mining, but chance played its part in enabling the *Star* to expose the true scale of the Gresford Disaster ahead of its rivals.

On that fateful Saturday, 22 September 1934, Geoff was living with his parents in Brymbo, a few miles from Gresford Colliery. This is how he describes events in his autobiography:

It was a cold rainy morning, about 5 o'clock, and I'd just had a very disturbing telephone call from my brother-in-law to be, Les George. His father, a surface worker at Gresford, had phoned home to suggest that Les should get in touch with me: there was something very wrong at the pit. 'It's full of dust and we can't phone through from the top of the pit to the bottom.' This coincided with another message from my fiancée, Verlie George. She was a staff nurse in the Wrexham Memorial Hospital and she, like everyone else in the Nurses' Home, had been woken up in the early hours to prepare for the emergency admission of up to 250 severe accident cases caused by explosions, burns and crushing. No further

explanation had been given but in a mining district none was needed.

As Geoff was getting his car out to travel to Gresford, a neighbour called George Moulder appeared in his working clothes and with a blackened face. He was on his way home from his shift in the furnaces at Brymbo Steelworks that had only recently been relit. When told what was happening he said he'd accompany Geoff in case there was something he could do to help. Geoff did not expect to be allowed on to the colliery property but to his surprise the policeman guarding the entrance waved him on. They concluded that the officer had probably assumed that George Moulder was a rescue worker being driven to the site from another colliery.

Geoff went into the lamp-room and asked the man in charge how many miners' lamps had not been returned. That would indicate how many men were still underground.

'Two hundred and sixty four,' he said and my heart missed a beat. In the cold rainy daylight, I saw a frieze of men and women waiting for news on bank tops overlooking the yard. Lorries were delivering men and tools – this seemed strange to me – thousands of conical red hand-held fire extinguishers. Not much help when a coal mine was on fire, I thought … After some searching around for stories of what had happened, though of course no official statements were yet being made, I was told some men had got out of

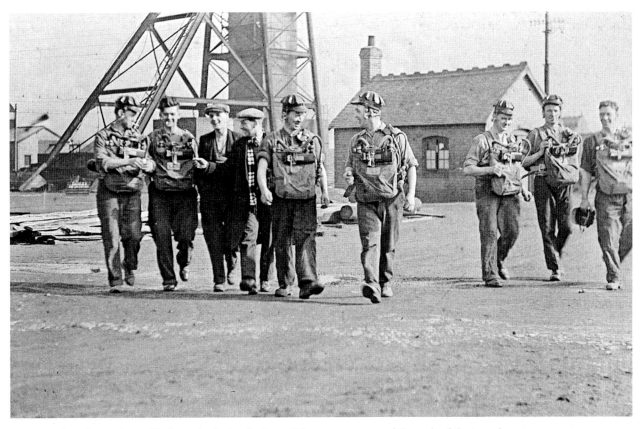

Rescue workers from other collieries arrive in Gresford, possibly unaware as yet of the scale of the tragedy

the pit from a part not affected by the explosion, had gone home to reassure wives and relatives, returned to Gresford and been ready to go down to Dennis Pit to see if they could help.

Geoff had seen all he wanted. He rushed off to the *Wrexham Star* office and wrote his account. Two special editions of the paper were printed on a primitive flatbed machine. Geoff's eyewitness account filling the front page is credited to 'A *Star* special representative' and opens with this paragraph:

A terrible disaster occurred at about 1.40 this morning at the Gresford Colliery when 240 men were entombed. Up to 9.30 this morning 11 men had been

brought up dead and, as I stood there watching the procession of stretchers with their tragic burdens, there were harassing scenes at the pit-head.

Crowds of relatives were standing in the pouring rain, drnched after miles of walking and waiting, some of them knowing in their hearts that they were waiting in vain.

Geoff was surprised to find that the official casualty figures being released the next day stood at seven dead and 102 colliers trapped underground.

On the Saturday afternoon Wrexham were playing a football match at the Racecourse ground. Some of the miners killed had asked if they could work the night shift in order to have their afternoon free to see the match. Geoff attended the match despite his sleepless night. Some of the spectators had seen the special edition of the *Star* and accused Geoff of painting too gloomy a picture of events at Gresford. As Geoff wrote in his autobiography:

Some of them thought that hundreds would have been rescued from the pit. But having been there and seen the situation, I knew that there was no hope of that. And unfortunately I was right.

All the Wrexham area was paralysed with everyone stunned. I remember Rhosddu where every other house had lost someone, they were streets of the dead. When the disaster fund started paying money to the widows, what the women of Rhosddu wanted more than anything were pianos. Some people criticised them for this but if somebody wanted a piano I could see no earthly reason why they shouldn't have one…

It has been said that history is for the community what memory is for the individual, and in that sense this account, not of what motivates kings and statesmen but of the experiences that give a small community its attitudes, values and traditions, is an account of the shaping of my values and my life.

From words to pictures

There was no dramatic turning point in Geoff's career when he decided that in future he would tell his stories in pictures rather than words. It was more a transition than a damascene conversion, and he continued to write articles long after he'd established himself as a photographer. And although it was a love of writing that led him to a career in journalism, he was familiar with the world of cameras from early childhood because of his father's influence. He told his interviewer at the National Library:

> I'd always been interested in photography because my father had taken a lot of pictures as a young man. One of the best wallopings I got as a child was when my brother and I went to my father's sanctum in our first house, the room where he kept his papers and private things. We found little boxes of cardboard that looked interesting. So we tore the paper off them and found that there were funny little white things inside that went black as we looked at them. These were quarter-inch plates, forerunners of film, that he'd acquired for his camera. He'd got them before the First World War and had kept them because they were impossible to get afterwards. When he found out that we'd ruined all his stock by exposing them to the light, we really got into trouble.

When I asked him in 1975 how he had started taking photographs for newspapers, he recalled an incident when he worked as a reporter for the *Western Mail*. He was sent to cover a story at a golf course near Jersey Marine, Swansea, accompanied by a photographer called Mutt Abrahams. Mr Abrahams was a ladies' man who decided to sneak off on some amorous adventure, leaving Geoff his camera and a set of instructions. That, said Geoff, gave him his first taste for illustrating his stories with his own pictures.

It was during his time with the *Wrexham Star* that he began to do this more regularly. Nobody on the paper had much experience of taking pictures but Geoff, thanks to his father, had a better inkling than his colleagues. Alf Fletcher, one of the paper's proprietors, owned a plate reflex camera and asked Geoff to use it to take pictures for the *Star*. One of his first pictures to appear in print showed the relighting of the blast furnace at Brymbo Steelworks after the stoppage. When Fletcher decided to set up a darkroom in the cellar of his house, Geoff browsed through his father's old photography books, including his *British Journal of Photography Annuals*, and gleaned enough information to complete the task.

Getting the pictures on to the plates for printing was a cumbersome process. Geoff would develop the pictures in Fletcher's cellar; small prints would be sent to a company in the Midlands who would convert them into photographic blocks. The blocks would be sent back to Wrexham and the pictures printed in the *Star*.

One of Geoff's early pictures showed rescue

workers arriving at Gresford Colliery after the disaster. That image survived, but many others were lost when a few years later a 'philistine' colleague in Oswestry threw a stack of glass negatives on the dump. Geoff resolved that from then on he would take care of his own negatives, a decision with far-reaching consequences. The archive that exists today owes as much to his organised filing system as to his photographic skills.

In 1939 he bought a Leica IIIb, a classic rangefinder renowned for its unrivalled precision. Geoff, towards the end of his life, could name virtually every camera that he ever owned, and reminisce about them in minute detail. But the Leica had a special place in his heart: 'It became a part of you. You didn't have to think about it, only use it. It's like driving a car – you don't have to ponder where the gear stick should go next.'

It took some practice to master the techniques that became second nature. With some of the early cameras, correct focusing depended on working out the distance between the camera and the subject. Carrying a measuring tape everywhere was not practical. The eye had to be trained to assess distances, and Geoff set about the task with his customary thoroughness. Bystanders would look slightly bemused at a grown man staring at a lamp-post, striding purposely towards it, measuring the distance in one-yard steps. He would repeat the procedure from various distances, sometimes banging his head against the post. Ensuring pin-sharp focus was never a problem after that.

Over the years cameras evolved that took over many of the responsibilities that used to depend on the operator. Geoff was never fazed by technology but would never surrender control of camera settings, preferring to set everything manually. When I worked with him first he was using Minolta SLR cameras but switched to Nikon soon afterwards. A few years later he acquired a Hasselblad, an elite medium format camera which he was proud to show me but never carried around for everyday use.

Woodalls Newspapers

The final straw for the *Wrexham Star* came, ironically, through an economic upturn and a relighting of the furnaces at Brymbo Steelworks. There was no longer a pool of redundant steelworkers happy to sell the paper on street corners, and the boycott imposed by newsagents at the behest of Rowland Thomas was still in force.

Early in 1936 the *Star* ceased to exist as an independent title when it was merged with Wrexham's oldest newspaper, the *Wrexham Advertiser*, to create a new title, the *Wrexham Advertiser and Star*. The *Advertiser* had been bought three years previously by Rowland Thomas, managing director of Woodall, Minshall and Thomas, who also published the *Wrexham Leader*. The struggling *Advertiser and Star* ceased publication in 1946, whereas the *Leader* went from strength to strength.

These changes worked well for Geoff Charles who was invited by Rowland Thomas to join his growing newspaper empire from their base in Oswestry. He would be employed by Woodall, Minshall and Thomas, later renamed Woodalls Newspapers and finally North Wales Newspapers, for the rest of his working life.

Rowland Thomas, born in Oswestry in 1887, had come home from the First World War to succeed his father as director of Caxton Press and chairman of Woodall, Minshall and Thomas. Originally the company only produced the Oswestry-based *Border Counties Advertizer* but had started the *Wrexham Leader* in 1920 and developed a network of local papers that eventually covered much of north and mid Wales. Rowland Thomas was not a Welsh speaker but felt a strong commitment to Wales and its language. In 1932 he bought the title of a small local paper called *Y Cymro* in Dolgellau, and relaunched it as a national Welsh-language weekly. Thomas also bought the publishing company Hughes a'i Fab which produced several popular Welsh books including *Llyfr Mawr y Plant*, the most iconic Welsh children's book of all time. In 1947 he was elected to the Gorsedd of Bards at the National Eisteddfod for services to the Welsh language.

In his early days in Oswestry Geoff worked mainly as a photographer supplying pictures for the company's local papers and occasionally for *Y Cymro*. He was beginning to establish himself as a photographer and had set up a darkroom in his home. His technical expertise would have pleased the enterprising Rowland Thomas who had purchased a machine to make photographic blocks at the plant. This spared the company the time-consuming chore of sending prints to a firm specialising in this work; they could now get pictures in their papers more rapidly than their rivals and produce better-quality prints.

Much of Geoff's photography at that time involved getting as many faces as possible on to the page and there was little room for creativity. People

loved seeing themselves and their friends and families in the paper and that was what boosted sales. But assignments for *Y Cymro* could be a welcome change from the routine pictures of weddings, village fêtes, tea parties and school trips. His first job for the paper was back in January 1936 when the editor asked him to go to Llandudno to take a picture of the Reverend Lewis Valentine, one of three prominent Welsh nationalists about to stand trial for burning an RAF training base being built at Penyberth on the Llŷn peninsula. Valentine, Saunders Lewis and D.J. Williams had resorted to direct action after widespread constitutional opposition to the project had been ignored.

The trip to Llandudno was an adventure that Geoff would never forget. His fiancée Verlie went with him on a bitterly cold day in an open-top car, Geoff having supplied a hot water bottle to keep her from freezing. On the way home the car started boiling and the water from the bottle had to be sacrificed to top up the radiator.

There was another setback when the Rev. Valentine decided he did not want to be photographed. He preferred to divert attention towards his little daughter Gweirrul who was photographed sitting in her father's chair, a chair that would soon be empty for a period of nine months.

Geoff wrote an account of the visit in English, with colleagues at the office translating it into Welsh. The story was attributed to '*Y Cymro* correspondent' and there was no mention of the photographer. The account is quite emotional, describing how the happy and welcoming family was about to be disrupted, with the father they adored 'sent away to a place designed for crooks and villains rather than scholars and gentlemen'. Unfortunately, the originals of the pictures taken that day have not survived.

It would be some years after that before Geoff was employed specifically to take pictures for *Y Cymro*. Before that his career, like that of so many others, was disrupted abruptly by world events.

The war years

At the outbreak of the Second World War, both Geoff and his brother Hugh volunteered for the Royal Navy. The Admiralty were happy to recruit Hugh, who went on to serve on convoy escort duty in the Atlantic and the Mediterranean. Geoff, because of his health history, had to be examined by a TB officer. Although an X-ray did not detect any problem with his lungs, the authorities decided that the confined spaces of a ship at war were not suitable for someone with a history of TB. 'I can't say that I was sorry,' said Geoff, who spent the war in the relative tranquillity of rural Montgomeryshire.

In January 1939 he moved to live in Newtown with his wife Verlie and baby daughter Janet. He had been sent there to help revive the *Montgomeryshire Express*, which Rowland Thomas's company had bought in 1933. Although his official designation was manager rather than editor, Geoff was responsible for several aspects of the paper, whose circulation had been in decline for some years. He set about his task with boundless energy, operating at various times as reporter, sub-editor, photographer, motoring correspondent, advertising rep, circulation officer and founder and editor of a highly successful children's page that he had set up. In addition to all this he still found time for occasional trips to other parts of Wales to take pictures for *Y Cymro*.

He enjoyed his time in Newtown, as he makes clear in his recorded interviews with National Library staff. He saw the *Mont Express* as an opportunity to implement some of the things he had learned during his journalism course in London, although this caused some friction between him and more conservative colleagues at the company base in Oswestry. In those interviews he says that he had managed to raise the circulation of the paper from 1,500 to 12,000 copies and the weekly advertising revenue from £27 to £460.

One of his most successful innovations was what he called the Kids' Corner. He was fond of children all his life, and by the end of his stay in Newtown he had three of his own – Janet, John and Susan. Janet and John, unbeknown to them, became part of the 'family' of Kids' Corner. John, who became a history teacher, has early memories of that half real, half imaginary world where the division between their father's home life and professional life had become blurred: 'He was a great storyteller. The stories would be devised for bedtime, every story featuring four boys, Hector, Henry, Horace and Ginger. He would lie on the bed telling us the stories and would fall asleep himself while we were still awake and wanting to know what happened next.'

Young readers would look forward to the weekly adventures of four characters who had now become Horace and Henry, Janet and Johnny, and Geoff started organising events for them in different parts of the catchment area. Geoff recalled: 'We would hold parties for the children in Machynlleth, Newtown

and Llandrindod, and Janet and John would come there with me. On seeing that these two were real, children who were there were more likely to believe that Horace and Henry also existed in some mysterious way.'

Separately from his work on the *Montgomeryshire Express*, he would take his own children on visits to places of interest, including a railway station, bus station, police station and fire station, explaining to them how these places worked. This developed into a weekly feature in *Y Cymro* in a slot called 'Y Cymro Bach' [The Little Welshman]. 'Joni', based on his son John, would be the main character. John said: 'We felt privileged as children that these doors were opening for us. I would have my pictures taken in various locations but didn't realise I was being used as a stooge. In the articles I would ask all sorts of questions, which was an opportunity for him to explain things to other children who were reading the paper.'

One of the successes of the Kids' Corner was a lively letters column, an idea which Geoff had borrowed from the *Daily Mirror*. 'I was a big admirer of the *Mirror* in those days and they had a letters column, the "Old Codgers",' said Geoff. 'At the end of every letter they would add some funny comment. To try and engage the interest of the kids I started doing the same thing, adding a line or two of something a bit daft after their letters to try and get them to write more. This worked very well.'

Despite their townie upbringing, Geoff and his siblings were never completely out of touch with rural ways. Every year when the school closed for the summer holidays a car belonging to the Brymbo Water Company would call for the Charles family and take them to a farm on the slopes of Mynydd Hiraethog. Penylan farm was close to one of the water company's reservoirs, and although only a few miles from home, they would be immersed in a way of life far removed from the clamour of coalmines, steel furnaces and trains. Mrs Charles and the children would spend much of the summer at Penylan, with their father back at work in Brymbo during the week but joining them at weekends.

In *The Golden Age of Brymbo Steam* Geoff paints a fascinating picture of how the town children adapted to this strange new world. He describes their unsuccessful attempts at milking a cow, how they churned milk until their arms ached without making any butter. They were taught to snare rabbits, witnessing death at first hand for the first time. They accompanied a shy old farmer as he took his cow to a bull, asked awkward questions and were amazed that such a peculiar ritual could bring a calf into the world.

Those summers in the country during the First World War would serve as a kind of apprenticeship, in Geoff's case, for what followed during the next war. Newspapers have to reflect the interests of their customers, and the *Montgomeryshire Express* served a largely rural readership. The same was true of *Y Cymro* and the *Border Counties Advertizer*. Although Geoff lived in towns for most of his life, he had a natural affinity with farmers and country people

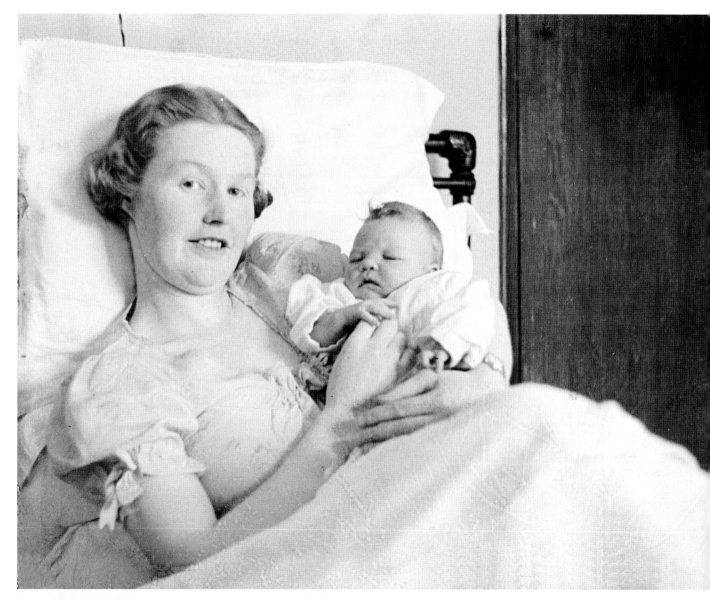

Newborn Janet with her mother, Verlie Blanche Charles, May 1940

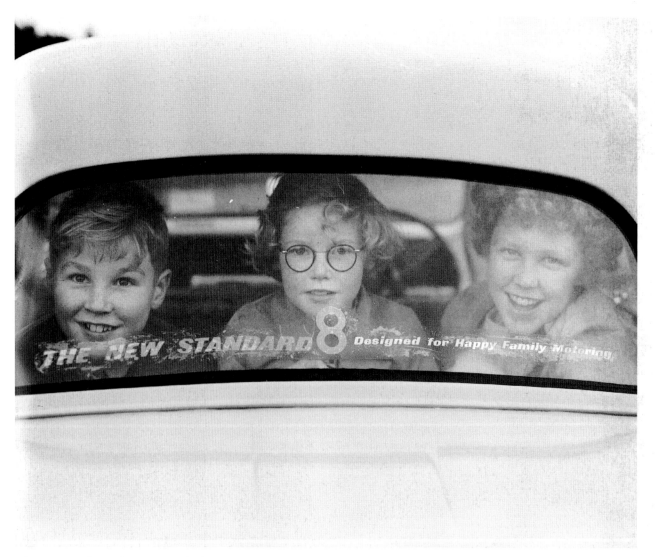

John, Susan and Janet in a new Standard 8 car being road-tested by their father, 1953

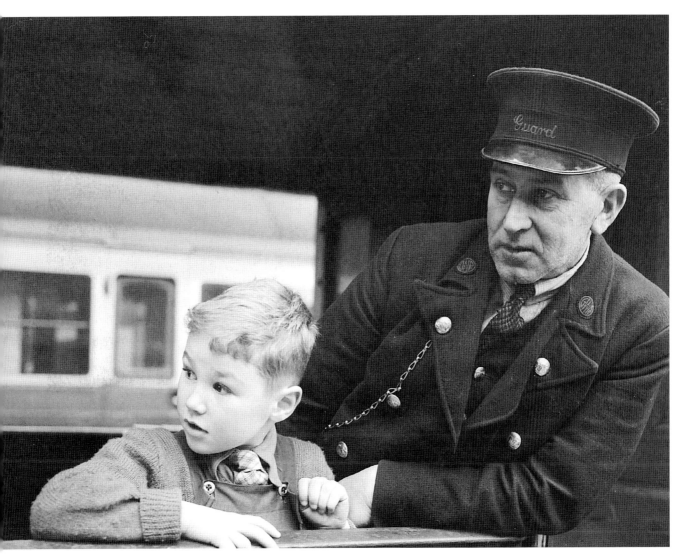

'I'm in the cab of a railway engine, a real live steam engine, with the smell of hot oil and the heat of the firebox and a ball of cotton waste to wipe my hands on.' Geoff's son, John, recalling the day he travelled on the Welshpool and Llanfair Caereinion Light Railway

but never pretended to be one of them. He was comfortable in their company and got to understand their ways without losing his outsider's fascination with their world.

This was the period when he developed contacts with the specialist farming press and started contributing stories and pictures to publications like the *Farmers Weekly*. He had read in a book on freelance journalism that the best way to succeed in that uncertain market was to specialise in one subject. Agricultural and countryside articles became his lifelong speciality. This freelance activity does not appear to have caused any conflict between him and Woodalls, his employer. Some of their own papers and magazines, like *Country Quest* and *Welsh Farm News*, would have benefited from Geoff's contributions and they would pay freelance rates on top of their salaries to staff who provided articles for these. They would not object to Geoff contributing to publications outside their group, provided this did not interfere with his duties to Woodalls. During my time working with him I found his contacts with magazines like *Farmers Weekly* and the *Radio Times* an advantage as they generated ideas for stories in *Y Cymro*.

The Second World War brought many changes to the mid-Wales countryside. These were reflected in the *Montgomeryshire Express* which filled its pages with stories about food rationing, blackouts, gas masks, the arrival of evacuated children from English cities, Home Guard manoeuvres, the boys in uniform home on leave, and those who would never come back.

One positive effect of the war was to elevate agriculture to a new status. After years of neglect which saw Britain importing much of its food, German submarines forced a change of policy. Self-sufficiency was the goal, with the government urging farmers to increase their production. The *Montgomeryshire Express* carried regular adverts with messages such as:

Ploughing of farms / Is as vital as arms

and

Farmers, plough by day and night,
Play your part in the fight for right

Schoolchildren took up gardening as part of the 'Dig for Victory' campaign. Knitting socks for soldiers and even making jam were seen as part of the war effort. Through his new contacts in the farming community, Geoff's involvement in these campaigns began to extend beyond his newspaper work. He became a member of the War Agricultural Executive Committee, commonly known as the War Ag, charged with trying to educate farmers to adopt more productive methods. Geoff was co-opted on to the Technical and Demonstration Sub-committee whose remit was to demonstrate the new production methods to the farming community.

How farmers reacted to these instructions is not recorded, but Montgomeryshire played a significant part in doubling the arable acreage of Wales during

the course of the war. There were massive deep ploughing schemes at Buttington and Llwydiarth near Welshpool, all recorded in words and pictures by Geoff Charles in the *Montgomeryshire Express*.

The paper even published a 'personal' message to Montgomeryshire farmers from Prime Minister Neville Chamberlain just before his resignation in 1940. Appealing for increased output, he promised that the government would ensure that farmers got a fair price for their products, which would enable them to employ the necessary labour.

It was during his time in Newtown that Geoff became involved for a while in party politics. His father and grandfather had been active supporters of the Liberal Party. Woodalls Newspapers was also a Liberal paper and when he settled in the solid Liberal constituency of Montgomeryshire, it was no surprise that he was drawn into party activities. Journalists are usually coy about revealing their party affiliations and Geoff, when I knew him, got on with members of all parties. But in 1945 he was instructed by his boss Rowland Thomas to do all he could to ensure that local boy Clement Davies kept his seat in the July general election. Geoff was happy to oblige, not only by giving the candidate ample coverage in the *Montgomeryshire Express* but also helping to run his campaign. Labour decided not to stand in order to prevent a Tory win and Davies retained the seat comfortably and became leader of the UK Liberal Party.

In 1948, just before he left Newtown, Geoff took an intriguing if rather frightening news picture. It shows two tall men in dark suits about to enter a car, the man in front smiling at the camera. It seems an innocent enough scene, but why is the same man carrying a white rose in his left hand? The picture was taken during a murder investigation near the border town of Knighton. The decaying body of a labourer had been discovered at his remote house by neighbours who alerted the police after noticing swarms of flies inside the window. The man had been poisoned by a prostitute he had befriended in Manchester and persuaded to come and live with him. Geoff Charles turned up at the scene unannounced and arrived just as two Scotland Yard officers were leaving. Geoff recalled: 'As I approached the house the two officers were walking down the garden path. One had a white rose in his hand. He explained to me that the stench in the house was terrible – it was a hot summer. So he'd cut this rose in the garden before he went in and held it in front of his nose. It was just like the old days when judges used to carry nosegays when visiting filthy prisons. I was lucky. I had my picture and my story.'

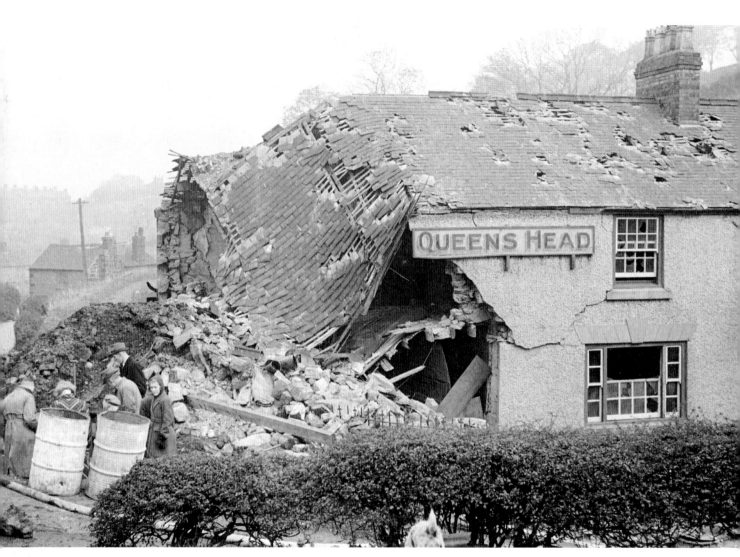

The Queens's Head pub, Brymbo, wrecked by a German bomb, 1941

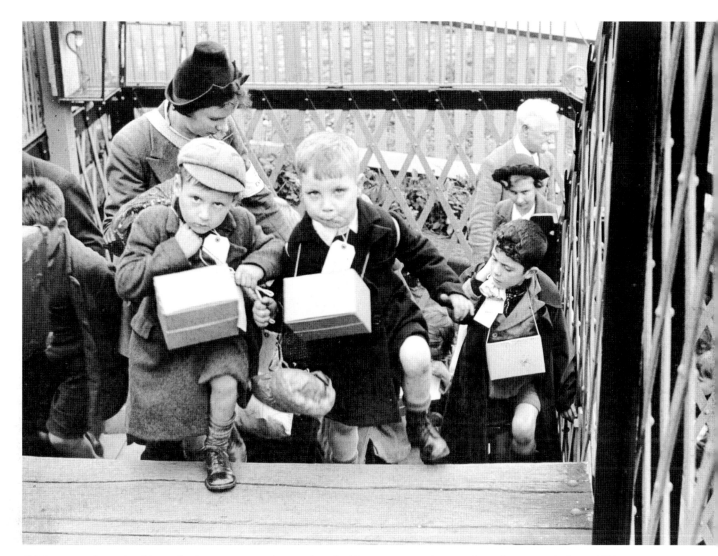

Child evacuees from the cities arrive in Newtown station, equipped with name tags and gas masks at the outbreak of war, 1939

Pupils of Trewern school, near Welshpool, pick rosehips from the hedges as part of the war effort to produce more food

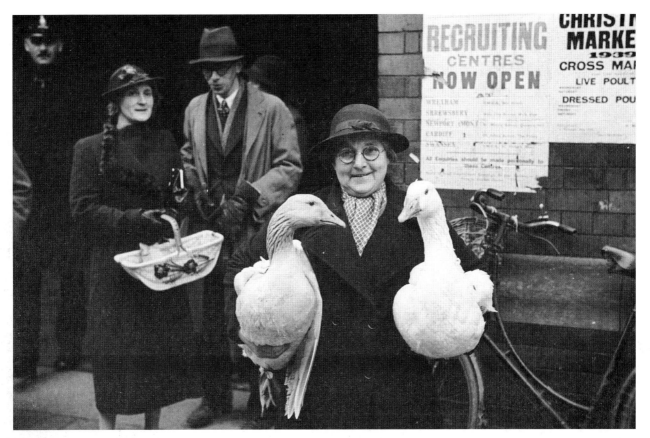

Food shortage does not seem to have had much of an effect on Oswestry's Christmas Market in 1939, although the recruitment poster is a reminder of world events

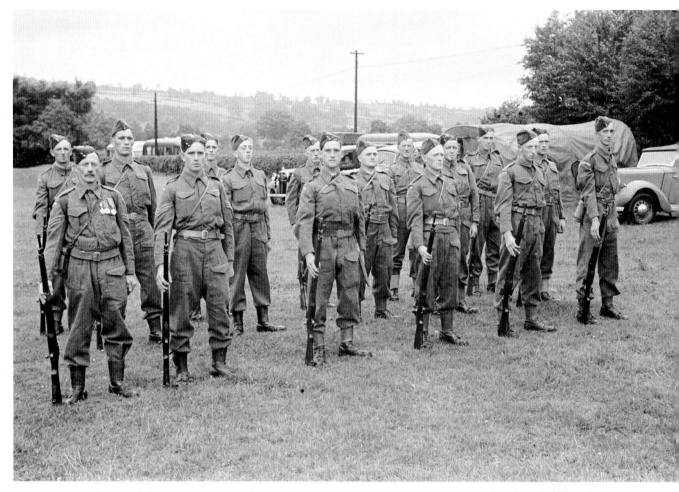

Home Guard manoeuvre, Penybont Fawr

Local children and the gamekeeper examine parts of a bomb that fell in the Caersws area in 1940. Newspapers were banned from disclosing the exact location

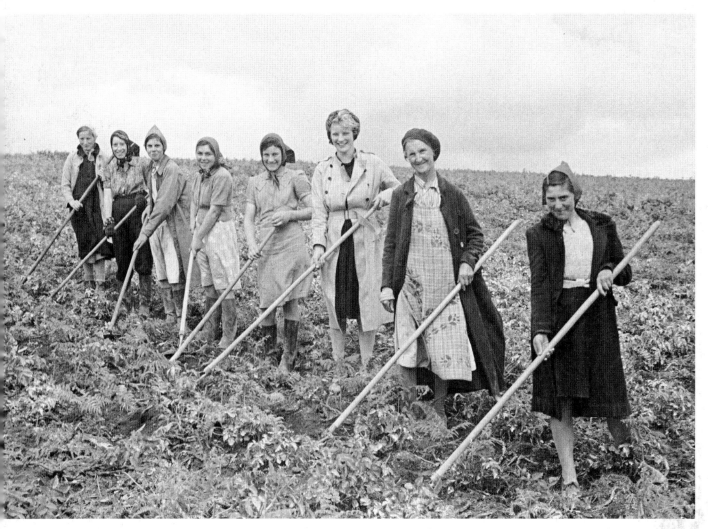

By 1942, 80,000 women in the UK had volunteered to join the 'Land Army', including this
group trying to fertilize unpromising land at Buttington near Welshpool

Schemes to grow potatoes on a large scale were started in Buttington and Llwydiarth in 1940. Within two years the
Montgomeryshire Express announced proudly that these areas were producing ten tons of potatoes a year

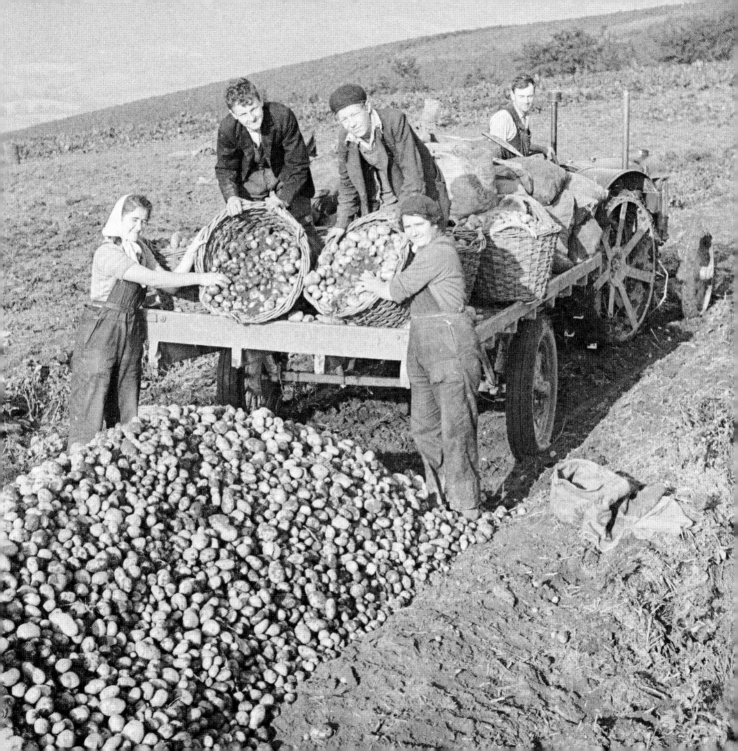

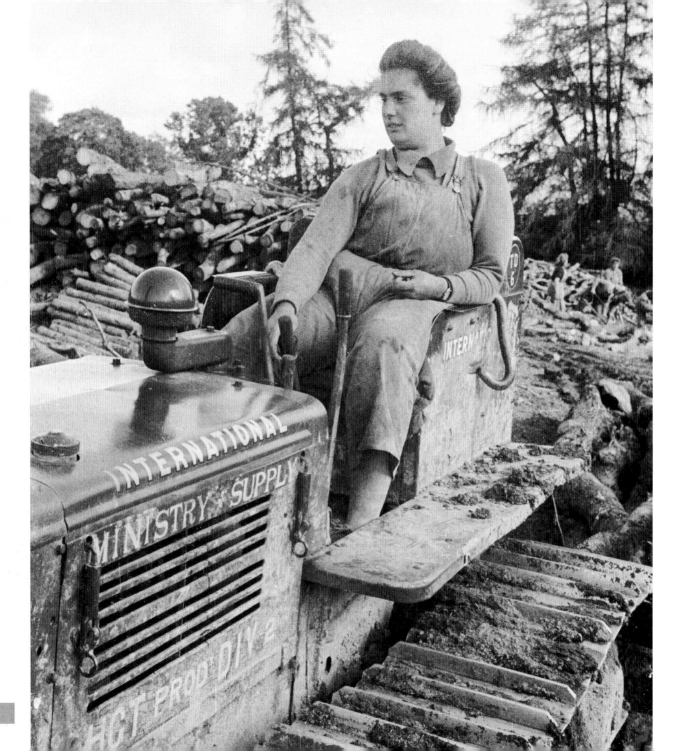

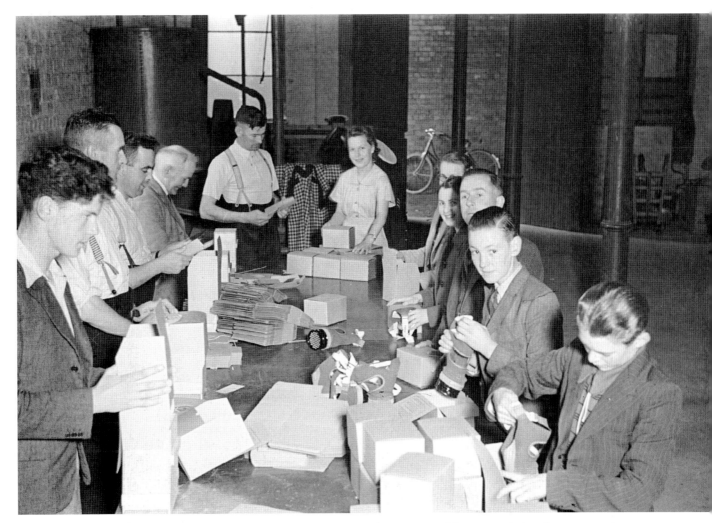

Volunteers assembling gas masks in a Newtown warehouse

The Land Army's Janet Bennet-Evans of Llangurig
moving timber in Welshpool

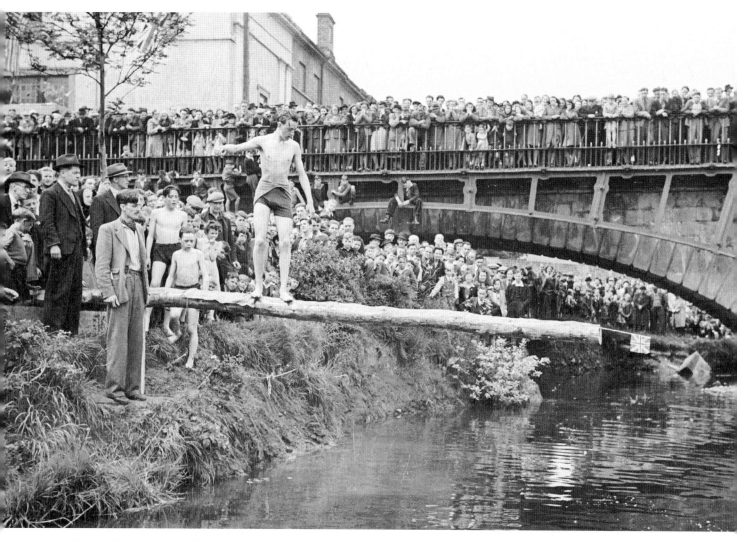

Crossing the Severn on a slippery pole as part of the peace celebrations in Newtown, 1945

Y Cymro

From Newtown Geoff and his family moved to live in Oswestry, where he was assigned to take overall charge of Woodalls photography output. This involved installing the most modern darkroom facilities for all the company's newspapers. He tried to introduce new ideas throughout the company but found that some of his colleagues were reluctant to adopt his proposed changes.

One of those colleagues was Ted Brown, a non-Welsh-speaking native of Pontypridd who had become the first full-time photographer appointed to work on *Y Cymro*. Before that he worked for a while for the *Montgomeryshire Express*, having settled in Llanidloes after war service in the Navy. He had got to know Geoff who advised him to ask Rowland Thomas for a job interview. He spent a short time working for the *Montgomeryshire Express* and was soon transferred to *Y Cymro*. He and Geoff were competitive colleagues who did not always see eye to eye. 'Personally we were the best of friends,' 88-year-old Ted Brown told me in an interview in 2004. 'But professionally we were like this,' he added, crossing his index finger.

One source of conflict was Geoff's decision as picture editor that all the company's photographers should use Leicas, the light, elite 35 mm cameras that had been used to great effect by photo magazines such as *Picture Post*. But Ted Brown had refused to abandon his trusted Voigtländer which was more cumbersome to carry around but produced clearer pictures because the negatives were larger. Nearly sixty years later Ted was still adamant that he was right. 'Leicas were fine for *Picture Post* but their printing methods were different,' he told me. 'They made our pictures look like barbed wire with all those little black dots.' Later all the company's photographers, including Geoff, changed over to press cameras that produced larger negatives. Ted Brown saw that as a kind of victory but Geoff insisted that the only reason for the change was that their stock of Leicas was getting old.

Despite their rivalry Ted Brown had the utmost professional respect for Geoff. 'There's no doubt about it, he was a very good photographer, nothing would hold him back,' he told me, but added, 'He was also lucky – the stories would land under his nose!' One example of that was a train accident involving the Irish Mail in Penmaenmawr in August 1950. Ted Brown recalled: 'The accident happened on a Sunday morning, and I'd gone to Barmouth to see friends. When I got back to the house they told me that they didn't expect to see me because they'd heard on the radio of a train crash in Penmaenmawr that I knew nothing about until then. So I rushed back to the car but by the time I got to Penmaenmawr things were almost over and Geoff had already been there. He'd been staying with his wife's family in Deganwy, so the accident happened on his doorstep.'

The photographers in the company headquarters in Oswestry included one called Herbie Southall, who also had arguments with Geoff who had accused him of leaving too much empty space around his main subject instead of filling the frame. Mr Southall had the serious handicap of being short-sighted. One dark night he drove his Austin 7 up a ramp and into a lorry parked on a street. He took a photograph of the situation, presumably using flash, before reversing out.

Geoff was not entirely happy organising the lives of other photographers and was happier taking photographs of his own. And this led to increasing involvement with *Y Cymro*. His desire to work for the paper was partly influenced by his father. Despite the reluctance to speak Welsh at home, John Charles always ensured that any adverts or notices for the Brymbo Water Company appeared in *Y Cymro*, which he claimed rather grandiosely was 'equivalent to *The Times*'. Geoff's loyalty to the paper was cemented by his friendship with John Roberts Williams, a key figure in the history of *Y Cymro*.

The two met for the first time around 1938 at the Recreation Ground, home of Pwllheli Football Club. What Geoff was doing in the area is unclear: although he covered several matches over the years, football was never one of his pet subjects. Rowland Thomas had asked him to attend a match in Pwllheli, not to cover the play but to meet John Roberts Williams who had been making his mark as a talented reporter on the *Caernarvon and Denbigh Herald*. Thomas had been advised to try and recruit him for *Y Cymro* and wanted Geoff's opinion. Geoff

was impressed with the 'tall, slim, dark, nervous but friendly' young man and reported back to his boss, 'We've got to get him to come over to us.' John accepted the offer of a reporter's job and subsequently steered *Y Cymro* through its most successful period. Geoff was best man at his wedding in 1945 and the two wives became friends and neighbours when the Williamses settled in Whittington near Oswestry. It was largely through John that Geoff became absorbed into Welsh-language cultural activities. In his 1984 interview with Beti George, Geoff said, 'The biggest debt of my life is to John Roberts Williams who introduced me to my heritage.'

The 1940s were a golden age for photojournalism. Television had not yet become a threat to print journalism, and newsy magazines such as *Picture Post* were hugely popular with their combination of impressive photographs and top-class writing. *Y Cymro* could not quite match the technical quality of these publications but reflected the trend to pay serious attention to picture content. One picture in particular epitomises this development. It was taken by Geoff Charles in September 1945, just before John Roberts Williams took over as editor.

The body of a farmer called Hywel Griffith was discovered in Llyn Dinas, a lake on his remote farm in Nanmor in the heart of Snowdonia. The inquest concluded that he had drowned himself when the balance of his mind was disturbed.

Hywel was the son of Richard and Catherine (Catrin) Griffith, whose remote farm, called Carneddi, had been in the family for generations.

Richard was a cultured, self-educated man, a poet who wrote under his bardic name Carneddog, and also contributed a weekly column under the title 'Manion o'r Mynydd' [Musings from the Mountain] for the local newspaper, *Yr Herald Cymraeg*.

Both in their mid-eighties and with failing health, they relied heavily of Hywel to help them run the farm. Three of their six children had died as babies and another died of TB as a young adult. After Hywel's death their only surviving child, Dic, who lived in England, visited the farm and concluded that the only way he could provide some comfort for his parents in their final years was for them to move to be near him in the industrial town of Hinckley in the Midlands. There they were well looked after but must have felt totally out of place away from their close-knit, Welsh rural community. Carneddog came home to be buried two years later and Catrin shortly after.

John Roberts Williams was then a reporter on *Y Cymro* and living with his parents in Pencaenewydd, about twenty miles from Carneddi. He had heard of the old couple's impending departure and asked Geoff to accompany him to meet them at the farm. As John Roberts Williams told me in a 2004 interview, the famous picture nearly didn't happen:

Geoff had been staying with me taking various pictures and was anxious to go home to Newtown to see his family. It was a Sunday by now, and Carneddog and Catrin were leaving the very next day. Geoff said he was tired and not too keen on doing any more pictures, but I managed to persuade him in the end. So off we went to this farm on a fine autumn day.

There were only the two of them there when we arrived and everything had been packed. Carneddog wanted to give me a book to remember him by, and the only one he could get hold of was called *The Marks on Christ's Body*, not a very interesting book. He was dressed in an old tailed jacket especially for the picture.

Geoff described the assignment in his interview for *Y Cymro* in 1975, and ten years later in a programme for a TV series called *Camera'r Cymro* on S4C:

When John and I arrived the house was very smoky. There was chaos everywhere, as you would expect when someone was about to leave and never come back. I thought to myself 'There's a good picture here somewhere' and I went round to assess the situation. I took pictures of him on his own, and then of the couple together. I kept talking all the time, trying to establish some rapport, which was very difficult. She was totally deaf and he had more important things than me on his mind. Their situation was there before your eyes.

They had both been preparing for us and had brought their best clothes out, clothes that had obviously not been worn for years. His coat was so old it was turning yellow. And there was a sprig of flowers on his waistcoat – he was frightfully smart. All I had to do was take them out into the garden and the picture was there to see. I went down on one knee and got them properly framed, with the tree above them and

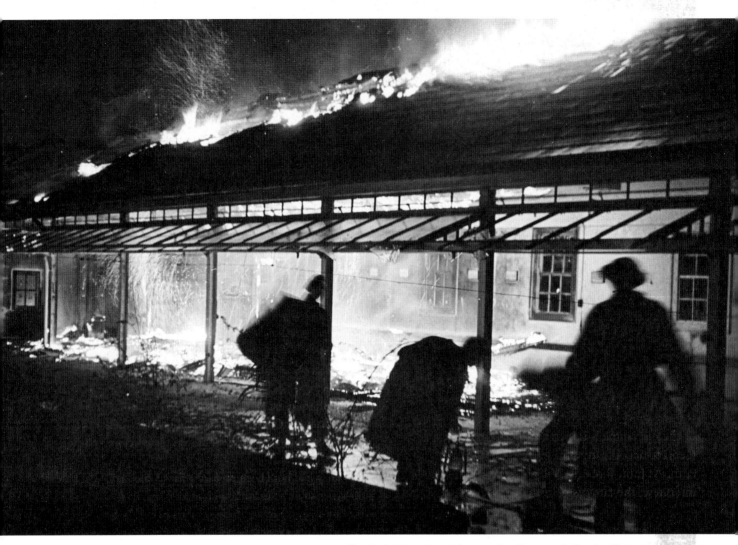

Gobowen Orthopaedic Hospital fire, 1948. 'I saw nurses pulling beds along the pathways. The place was furiously ablaze and the asbestos cement roof-tiles were exploding. There was no panic, only a steady flow of rescuers and rescued… We got back to the darkroom and produced a page of pictures for Wednesday's *Border Counties Advertizer*.' Geoff's notes, National Library of Wales

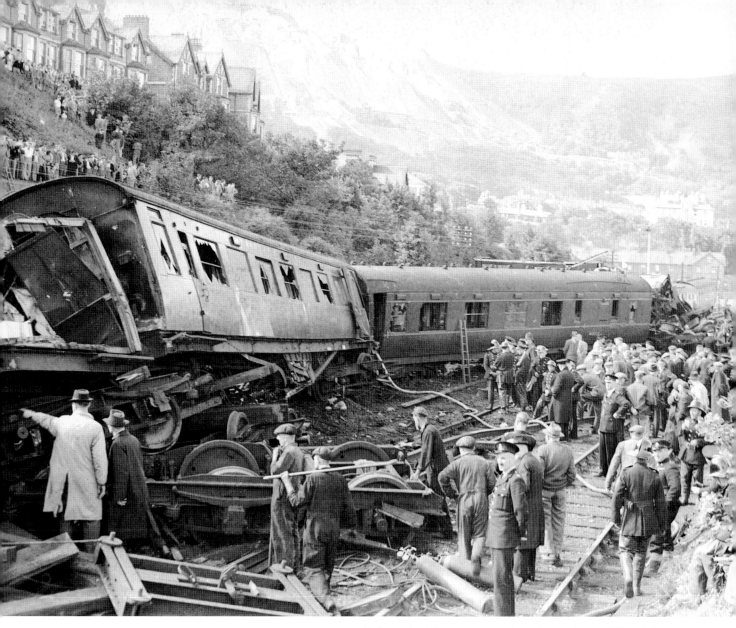

Train crash at Penmaenmawr where six people were killed, 1950

A policeman carries a white rose after visiting a murder scene in
Knighton, Radnorshire, in 1948. See story on page 35

53

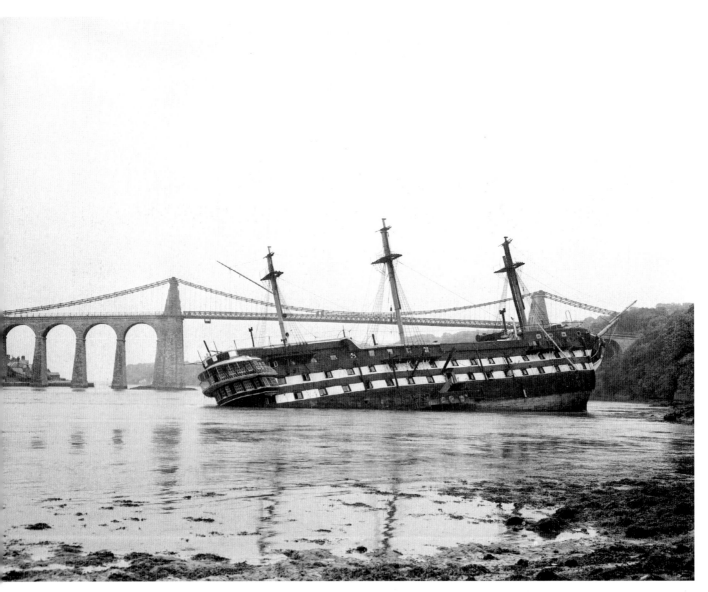

HMS *Conway*, a naval training ship, ran aground in the Menai Straits in 1953 while being towed from its mooring to Birkenhead for a refit

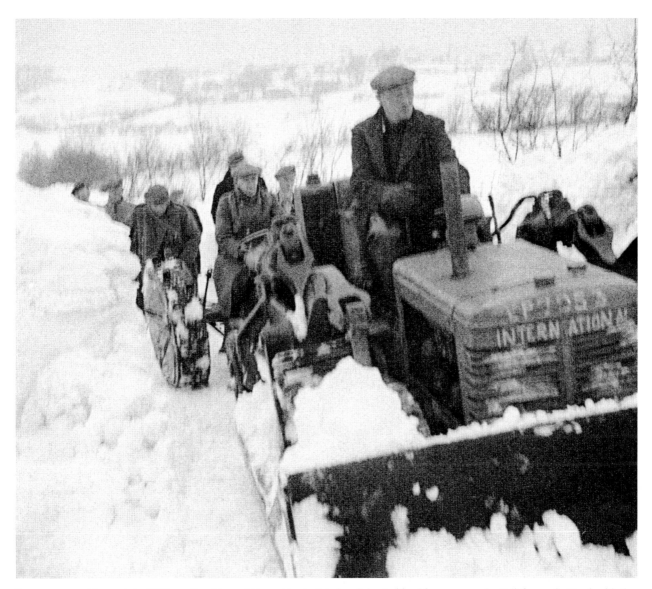

Severe snow and ice early in 1947 saw the village of Llanwddyn isolated and short of food for seven weeks. Relief came in March with the arrival of a bulldozer towing a tractor towing a sledge carrying five hundred loaves and other provisions

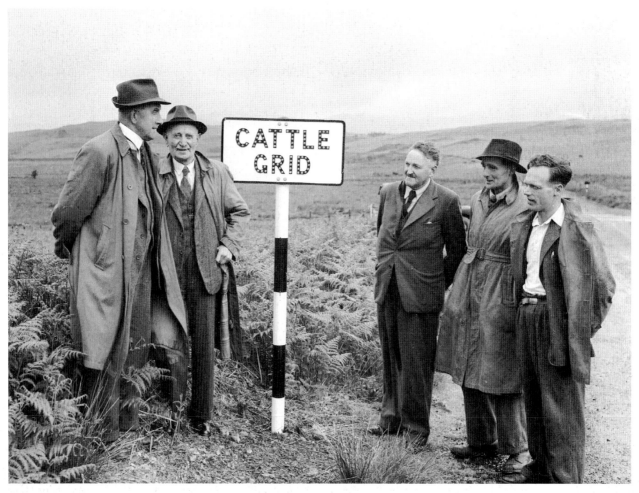

The official opening of what was claimed to be Britain's first cattle grid, on the
Berwyn mountain road between Bala and Llangynog in 1952

The Rev. J.W. Jones, vicar of Llanelltyd, near Dolgellau, is
rescued after his car overturned on a lane near his home

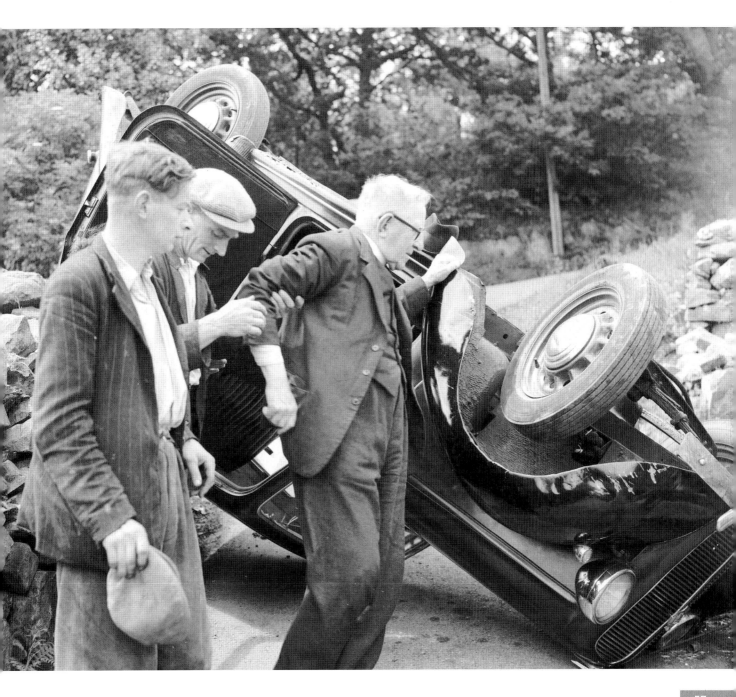

the mountains in the background. It was impossible to get her to hear anything; I could only say 'look over that way'.

The light was low so that I had to take the picture at a slow shutter speed, about a twentieth of a second, to get enough depth of focus to ensure that they and the mountains were sharp. There was a halo of light around their clothes and their faces and the hairs on Catrin's hands, showing that most of the light was coming from behind them. I wasn't at all hopeful about the picture. But in the darkroom as the film was being developed, I told the editor that I'd got the picture of the century!

When I was taking the picture and looking through the viewfinder at the light surrounding the couple, I remember thinking that this could look like double exposure – as if I'd taken a picture of the mountain, then a separate picture of the couple, then superimposed one print on top of the other and gone round with an airbrush to conceal the join. Some time later I sent the picture to some international competition, with an American judging. Having praised the picture he said it would have been placed in the highest category were it not for one thing: 'The photographer has pasted the old people on the mountain and airbrushed carefully around it… look carefully at their hands and at the old lady's face and you'll see the same aura of white which betrays that it's a piece of double printing.'

The first time John Roberts Williams saw the picture was when it appeared on the front page of the next issue of *Y Cymro*. As well as finding and writing the story, John had played his part by suggesting a line from a well-known hymn as a headline: 'Rwy'n edrych dros y bryniau pell' ['I look over the distant hills']. In a paper with a predominantly chapel-going readership, the headline touched a chord and added to the legendary status of the picture.

But John Roberts Williams wanted to share the credit for the picture's popularity with a third person, J.R. Lloyd-Hughes, who was joint editor of *Y Cymro*. Before becoming a journalist he had an artistic background and had studied at the Slade School of Art at the same time as Augustus John. It was Lloyd-Hughes who realised the picture's possibilities and printed it across most of the front page of the broadsheet paper, something that had never been done before by *Y Cymro*.

'It made such an impact that everyone wanted a copy,' said John Roberts Williams. 'The company had to find somebody else to do the printing as demand for prints was more than they could cope with internally.'

I asked Geoff in 1975 if this was the best picture he had ever taken. 'Yes, I think so,' he said. 'There's something in it that touches the heart. I realise that it's sentimental but there's something about it that goes right to the core of human existence.'

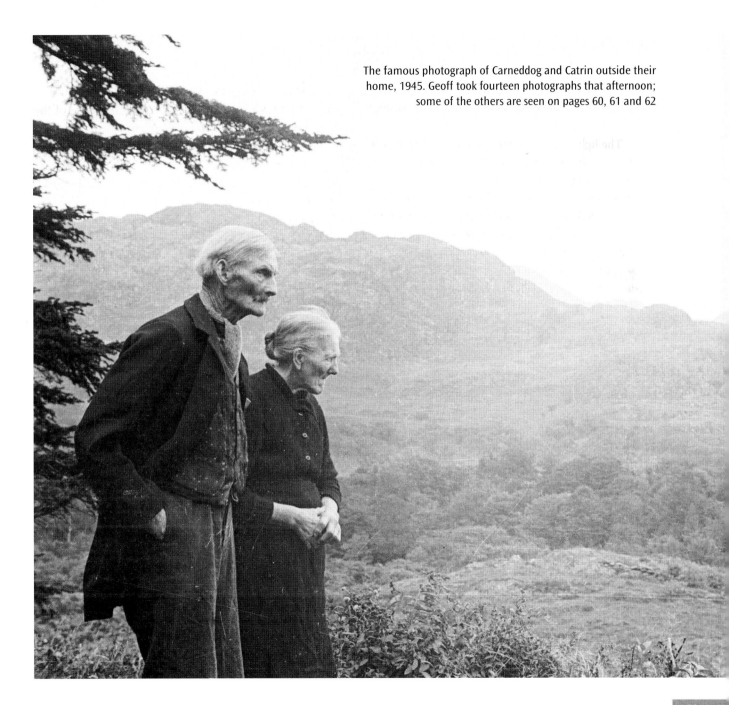

The famous photograph of Carneddog and Catrin outside their home, 1945. Geoff took fourteen photographs that afternoon; some of the others are seen on pages 60, 61 and 62

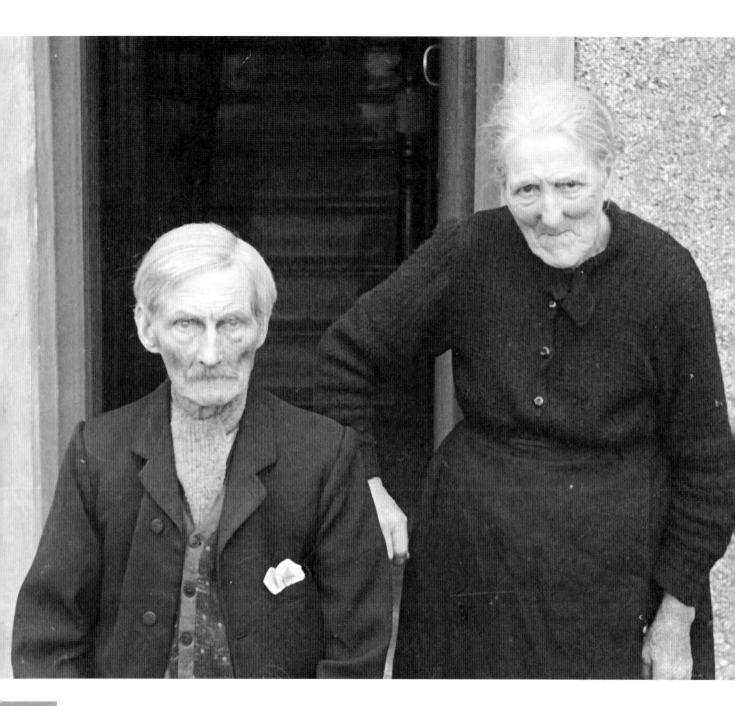

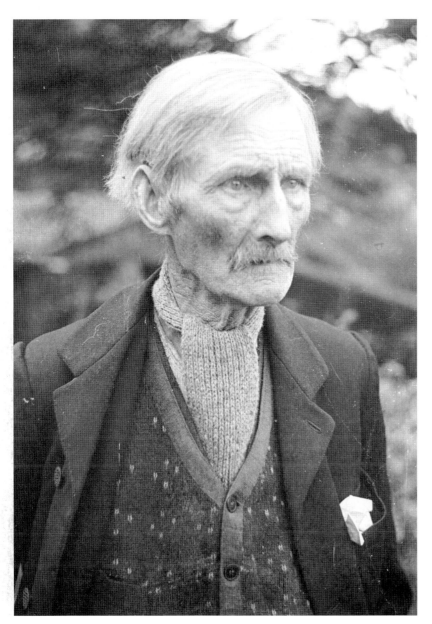

Movie-maker

John Roberts Williams became editor of *Y Cymro* at the end of 1945. It was still some years before Geoff started to work full-time for the paper, freed from his responsibility for the company's other publications. But soon after John Roberts Williams took the editor's chair, he and Geoff embarked on a major project in a medium in which they were both totally inexperienced.

A few years previously the first Welsh-language films had made their appearances. The cinema was the popular entertainment of the age, attracting huge audiences everywhere, including in Welsh-speaking areas. But the stock of films available in Welsh was limited. They included two short films made by Sir Ifan ap Owen Edwards, one of them publicising the work of Urdd Gobaith Cymru, the youth movement that he had established, and the other, *Y Chwarelwr*, portraying a quarryman's life in Blaenau Ffestiniog. Later, National Savings sponsored a film of a 'noson lawen', traditional music-based entertainment.

The popularity of these films inspired John Roberts Williams to work with Geoff Charles to make a more substantial documentary in Welsh to record a vanishing way of life in John's native Eifionydd, and boost the circulation of *Y Cymro*. They found a willing ally in Rowland Thomas who was always seeking new ways of promoting his papers.

Geoff had already been involved in this promotional work by going around various societies in mid Wales showing slides publicising the *Montgomeryshire Express*. A deal was struck with Rowland Thomas: if he was willing to buy them a cine camera, Geoff would use it to make promotional films for the company as well as their own Welsh-language project. The camera was bought for a hundred pounds, and sold for the same price at the end of the venture.

'It was an American camera made by Kodak and in very good condition,' recalled Geoff. 'They had taught us a bit about filming on the journalism course I did at London University but we were never allowed to lay hands on a camera. I had taken some pictures with a 16 mm film camera for the War Ag in Montgomeryshire, but apart from that I had no experience whatsoever in the field. So I set about studying a book on how to make documentary films.'

'Geoff had no bother at all,' said John Roberts Williams. 'The technology was no problem to him. Myself, I never owned a camera in my life. I have two left hands and anything with a switch is alien to me. But I was able to think in pictures. The only equipment we owned, apart from the camera, was a tripod, a big heavy thing that I had to lug around.' Sound recording equipment was beyond their means, so everything was filmed mute with an audio commentary and sound effects added during editing.

The documentary portrayed life in an Eifionydd community. It was centred on Freddie Grant, one of several children evacuated to the area to escape from

the bombing of Liverpool. Freddie, who learned Welsh fluently, assimilated without difficulty into the life of the village of Llangybi. In the film he is introduced to the heritage of his adopted community. John Roberts Williams wrote the script which was narrated by the poet and preacher Albert Evans Jones, known by his bardic name Cynan, a larger-than-life character with a booming voice to match. There were no actors, only ordinary people going about their everyday activities.

It was vital that the filming did not interfere with the everyday running of *Y Cymro*. The paper was printed on Wednesdays, which meant that John and Geoff's work on the film was confined to Thursdays, Fridays and weekends. The film had to be loaded into the camera in one-hundred-foot lengths, barely enough for two minutes of shooting. As Geoff said in an interview some years later, 'Nowadays you'd have eight or nine people in the production team, whereas John and I had to do everything ourselves.'

After the film had been sent away for processing came the editing stage, which proved even more challenging than the shooting. From Friday night until Tuesday morning they worked with few breaks in an improvised darkroom in Oswestry – an old garage with blacked-out windows. The technique they used was to put the negative film in one projector and a positive copy in another, project the pictures on to a wall and synchronise the two films. Then Geoff would cut the relevant parts, hundreds of lengths of film, hang them up in the right sequence and splice them together. Geoff was proud of the fact

that only one piece of film was lost, one that showed a shearer at work in Pencaenewydd.

The film was sent to United Motion Pictures in London for the final, professional editing and to print the negative. When he saw the finished product Geoff, the perfectionist, was not happy. In his rough editing he had left a few frames of pictures on either side of every join for the more refined editing by the professionals. But that refinement never happened, and Geoff's rough-cut from the garage in Oswestry is the one that still survives. 'This has pained me ever since,' said Geoff. 'It was too near our deadline to send it back, as we'd arranged to show the film to audiences. We had no choice but to let it go out as it was.'

The final stage in the process was to record and dub Cynan's commentary in Welsh and in English. The film had its first public airing at the National Eisteddfod in Dolgellau in 1949, but had already been shown to the press in Oswestry. The *Guardian* correspondent described it as 'a triumph of Welsh amateurism'.

John Roberts Williams told me in 2004 that he had never seen the English version of the film. Geoff had seen it but probably wished he hadn't. He watched it at the Board of Trade's cinema in Oxford Street on a visit to London, and was not impressed. 'Corny' was his description of Cynan's attempt to convey the spirit of the monoglot Welsh life of Eifionydd in English. 'I felt like crawling under my seat,' he said. 'This voice thundered on and on without respite. It was our fault. We should have realised that people would get bored by the non-stop

commentary, however good it was. We should have let the film run without words every now and then. We had let our enthusiasm run riot.'

The 50-minute film was not long enough in itself to satisfy audiences during its scheduled tour of Wales. People would expect at least an hour and a half's entertainment. To make up the gap they added some of the footage they had filmed to promote the company's papers. The montage opened with shots of lorries delivering large reels of newsprint to the printing works at Oswestry, showed the now obsolete hot metal printing process and closed with pictures of the papers being dispatched to newsagents. It was a novelty for people to see their own locality on film, and ordinary shots of streets in Newtown, Llanidloes, Llandrindod or Pwllheli were well received.

Years later National Library staff recorded Geoff's comments as he watched *Yr Etifeddiaeth* [*The Heritage*] and reminisced on the scenes with the excitement of someone viewing it for the first time. The sequences show the school, chapel and eisteddfod, timber yard, granite quarry and threshing on a farm, but Geoff's favourite memory was the day they filmed the sheep shearing at a farm in nearby Cwm Pennant. 'It was such a social occasion,' he said. 'All the neighbours came to lend a hand, thousands of sheep, scores of men arriving in old cars, and the women packing the wool. It was an important part of the life of Wales at the time, something that's died out by now.'

Their most ambitious movie venture, apart from *The Heritage*, was a visit to the Connemara region on Ireland's Atlantic coast. They made a twenty-minute film on life in the village of An Spidéal (Spiddal), an area of extreme material poverty but a wealth of Irish-language culture and tradition. They took with them Wil Vaughan, a Welshman who lived in Scotland and had been contributing a regular column for *Y Cymro*. In the film he is shown staying with a local family and observing their life and customs. He watches them trading at a horse fair, cutting turf for their fire and carrying it with a horse and cart. Stereotypes perhaps, but an invaluable record of vanishing worlds.

Some years after Geoff Charles had died, John Robert Williams revisited the family who had appeared as children in the film for an S4C documentary by Wil Aaron. By then the 'Celtic Tiger' had transformed the area's economy, giving the film added significance.

Geoff and John also filmed a football match between Wales and Belgium at Ninian Park, Cardiff. Geoff did not share John's passion for the game, but did a decent job of the filming. When he watched the footage of that match at the National Library, it became obvious that the only player he could identify was the Welsh centre forward Trevor Ford. He was more interested in the press photographers and their equipment, exclaiming at one point, 'Well, well, there's Ted Brown with his Speed Graphic!'

A photographer called Tom Morgan was appointed to tour Wales in a van showing the films at various venues throughout Wales and to Welsh societies in Liverpool, Nottingham, London and other English cities. During a viewing in Ammanford

Freddie Grant, the boy evacuated from Liverpool to Eifionydd who learned Welsh and became the central character in the film *Yr Etifeddiaeth / The Heritage*

Geoff met a man from *Encyclopaedia Britannica*. Having watched *The Heritage* film he told Geoff, 'Keep it in the archives for fifty years and it will be priceless.'

John Roberts Williams said, 'The tendency of journalists like us was to see the water without seeing the river. Carneddog and Catrin was a picture, not of an elderly couple but of the end of a period. And this film of life in Eifionydd was the same – the place has changed so much it has made the film historically important. Everyone thought things would remain exactly the same, whereas in fact we were recording a period that has ceased to exist.'

John Roberts Williams (right), editor of *Y Cymro*, and the paper's columnist, Wil Vaughan Jones, who featured in the film *Tir na n-Og*. The photograph was taken at the National Eisteddfod in Dolgellau in 1949 where the films had their first viewing

Lloyd George's funeral in Llanystumdwy in 1945, as the horse-drawn cortège carries the local hero to his final resting place on the banks of the River Dwyfor

Former Prime Minister David Lloyd George MP addresses a meeting in his Caernarfon constituency in 1940

The crowd at Lloyd George's graveside was so vast that some mourners climbed trees to get a better view

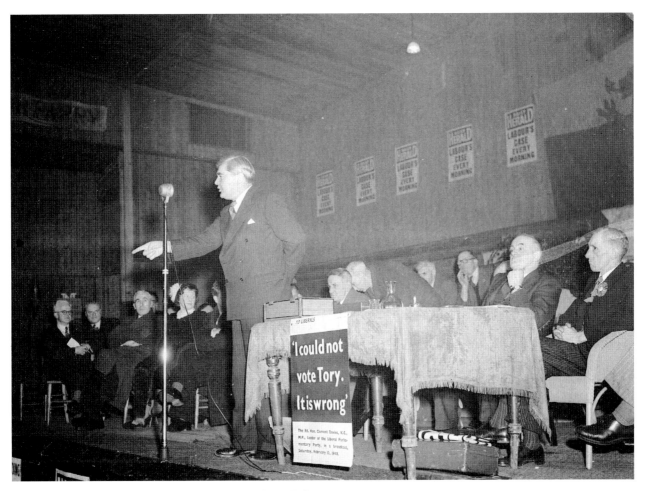

Aneurin Bevan, founder of the NHS, at a Labour election rally in Corwen, 1951

Billy Meredith, aged 76, kicks off a football match in Dyffryn Ceiriog in 1950. Billy, a coal miner from Chirk who went on to play for both Manchester City and Manchester United, was Welsh football's first superstar but never earned a salary to match

A gypsy family camped
near Bala in 1948

W.E. Parry was an expert at hedging, or hedge-laying. From Llanuwchllyn, near Bala, he had won several contests in the ancient craft and was pictured here competing in the Wrexham area in 1952

After the thatched roof of the Mason's Arms pub in Kidwelly caught fire in 1960, the owners advertised locally for a craftsman to build a new roof but got no response. Eventually they discovered Peter Slevin, from Donegal in Ireland. Peter's last job before the Mason's Arms was to thatch Anne Hathaway's cottage in Stratford-upon-Avon

In 1948, the last residents of Nant Gwrtheyrn, on the northern coast of Llŷn, were preparing to move to somewhere less remote after most of the granite quarries that had given rise to the village had closed. The village was only accessible along a steep and winding track and provisions were carried by horse-drawn sledge. Among the last residents (opposite) were William Owen, on the left, and George and Emma Earp. Nant Gwrtheyrn today has a new lease of life as the National Welsh Language and Heritage Centre and the road has been paved and improved

Geoff and an unnamed reporter caught up with a tramp called George Williams in the Dolgellau area and got him to tell them his life story. Born and raised in Liverpool of Welsh descent, he had taken to the road after his mother, son and daughter were killed by a German bomb in Liverpool docks. He praised the Welsh for their hospitality but complained that life was getting lonely as the old fraternity of tramps no longer existed

By 1955 there were only two postmen in the UK still delivering letters on horseback, and they were both working in Cardiganshire. Geoff Charles and reporter Dyfed Evans followed David Lewis Jones on his round in the remote Soar y Mynydd area. He only had eight houses to call on but his shift took nine hours

Thomas Williams sowing in the traditional manner in Chwilog in 1962. He had started to learn the skill at the age of thirteen but said it took years before he could cast the seed evenly. It took him a full day of brisk walking to sow a nine-acre field, which a tractor could do in two hours

Four-year-old Dewi (left) and Huw had a cow each to milk on the family farm at Llandderfel near Bala in 1959. The animals were called Corn Cam (crooked horn) and Ifor. The milk was used to feed the family's four cats

Two farmers seal a deal in the traditional manner at Oswestry livestock market, 1954

'He is the ideal boys' blacksmith. Big, burly, bespectacled and kind.' That was how Geoff Charles described William Jones of Aberdaron in *Welsh Farm News* in 1963. Wil used to shoe nine or ten horses in a day using centuries-old techniques. Electricity and oxyacetylene had taken much of the skill out of the work, and horses had now become so rare that shoeing one in a day would give him backache

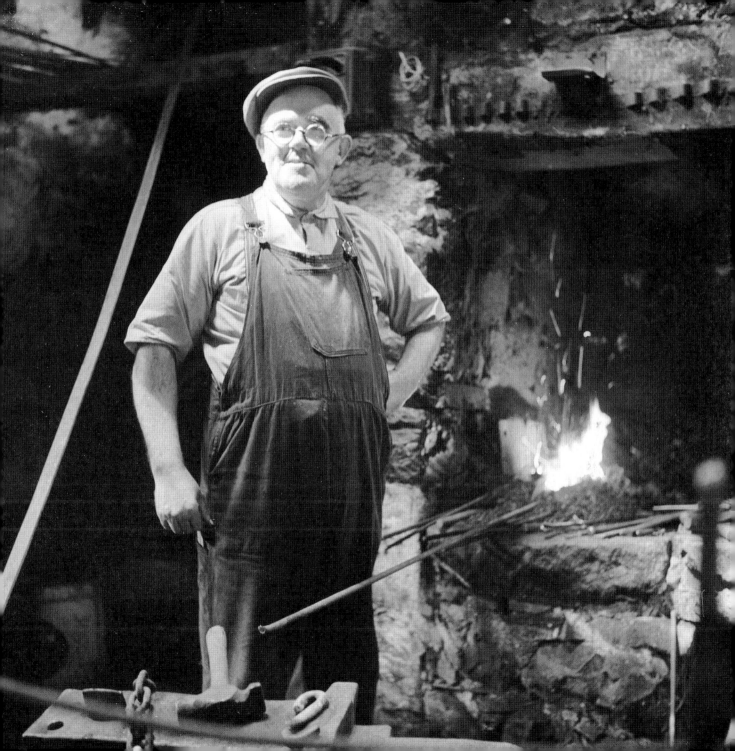

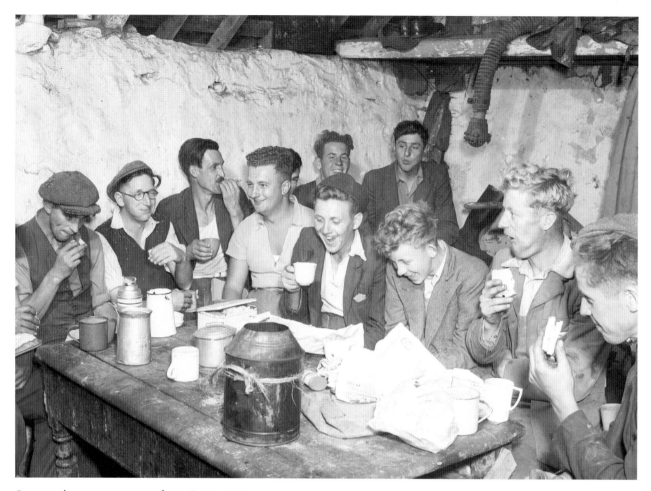

Communal supper on a potato farm, Gower, 1951

Golden age

The post-war period under John Roberts Williams's editorship is often remembered as the golden age of *Y Cymro*. After years of financial loss, the paper started to show a profit. Rowland Thomas was ready to invest in boosting the circulation to fulfil his dream of a thriving and popular Welsh national newspaper. In fact all the company's papers had seen signs of an unexpected mini-boom during the war. Because of the rationing of newsprint, which mainly affected UK-wide newspapers, many large companies diverted their advertising to local or regional newspapers. Everything from Woodbine cigarettes to Andrews Liver Salt was advertised in *Y Cymro*. Regional editions were printed for Anglesey, Caernarfonshire and Merionethshire, as well as a general edition for the rest of Wales. Welsh was still the everyday language over much of the country, the chapels and eisteddfodau were relatively strong, returning servicemen who had survived the war welcomed being reunited with their native language, and the challenge of television had not yet materialised. The circulation of *Y Cymro* rose to 26,000 and the Welsh publication at one time accounted for a third of the company's profit.

Photography played a leading part in the paper's success. Robin Griffith, a young trainee photographer from Edern in Llŷn, joined Ted Brown on the staff. Ron Davies of Aberaeron would contribute photographs on a freelance basis.

Dyfed Evans started working as a young reporter on *Y Cymro* in 1949 and for nearly twenty years he accompanied Geoff on most of his assignments. He remembers that Geoff's two main passions were trains and cars. He recalls Geoff doing road tests on new cars for *Y Cymro*, when Geoff would provide the words as well as the pictures.

He used to write about them in English and I had to translate the articles into Welsh, which involved finding new technical terms. He was also a very good driver who had passed the Advanced Driving Test. I remember he had an old soft-top Morris 8 that was dreadfully slow going uphill but once we got to the top he would go like the clappers on the way down.

In those days the two of us would go on a scout the length and breadth of the country looking for stories, calling for a chat with various people who would say something that gave us an idea for a story. There isn't so much of that kind of thing happening these days.

And, of course, he was in his element taking pictures of trains. I have no interest in them, but Geoff recognised every one, knew how many big wheels and how many small ones there were on every engine.

It was through his interest in cars that Geoff took the most dramatic, not to say horrific, pictures of his career. He had not intended taking pictures when he went on holiday to France in 1955 to watch the famous Le Mans road race. But he took a Rolleicord camera with him on the journey 'in case

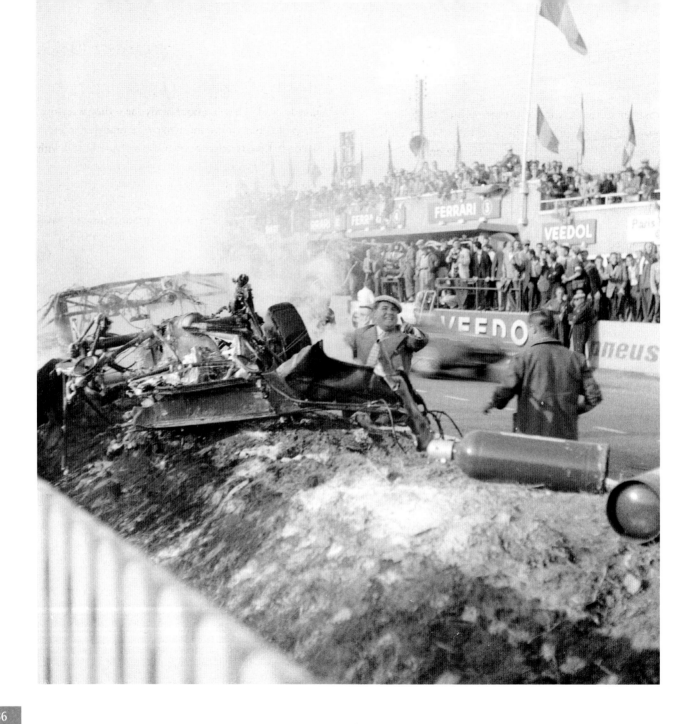

something happened'. What happened was the worst disaster in the history of motor racing, and Geoff was the nearest photographer to the scene. Eighty-three people were killed in a multiple crash when the Mercedes driven by Frenchman Pierre Levegh plunged into the crowd. This is how Geoff described the scene to me in 1975:

> Three of us had just been eating a picnic behind the stand and I was just loading a film in the camera when there was this deafening sound, like a child pulling a stick along a fence, and a large blue cloud rose above the stand.
>
> As we ran towards the scene, bits of tyres were flying in the air and people were screaming. The first thing I saw was a man on the road soaked in blood with a priest attending to him. Some people were already dead. They did not horrify me – they were not like bodies but looked more like wax models in a shop window. One gruesome scene was a severed hand with a watch still ticking on the wrist. My friends regretted that they were unable to do anything to help. But I had no choice but to do the instinctive thing and take pictures. I had shot three films without realising what I was doing. But some of the pictures show that my hands were trembling.

There was a train strike in Britain at the time which made it difficult to get the pictures back. But a reporter from the *Daily Mirror* got Geoff's negatives back to the UK where they appeared in *Y Cymro*, the *Mirror* and other publications worldwide.

The carnage at Le Mans, 1955

The Welshman

At the beginning of the 1950s Rowland Thomas decided to take advantage of the success of *Y Cymro* by launching an English-language version entitled *The Welshman*. In format it was identical to its Welsh counterpart, was also edited by John Roberts Williams and shared the same team of photographers and reporters as *Y Cymro*. Printed in Oswestry, the paper did not seek to serve the whole of Wales, but concentrated its efforts mainly on the industrial valleys of south Wales. It was part of Rowland Thomas's strategy not to market it in the northern areas where *Y Cymro* was strong, in case the competition harmed sales of *Y Cymro*, a decision which John Roberts Williams disagreed with. *The Welshman* shared an office in Westgate Street, Cardiff, with Hughes a'i Fab, the book publishing company that was also part of the Thomas empire.

Dyfed Evans, born and bred in Llŷn, had only been working as a reporter on *Y Cymro* for two years, based in the Caernarfon office. Suddenly he found himself dispatched into new territory and working in his second language. 'I was sent all alone to stay in lodgings in Swansea to work on this paper,' he said. 'I didn't know where to turn. After I'd found enough stories Geoff Charles would come down to take pictures to go with three or four of them. I left as soon as I could. The paper lasted a little while after I'd left.'

The Welshman caused some friction in Swansea where some of the established papers resented the competition at a time when a newsprint shortage was still a problem after the war. This may have been one factor in its demise after around nine months. In his book, *The Advertizer Family: A History of North Wales Newspapers Limited*, Robbie Thomas, who became managing director of Woodalls, said that the paper had fallen well short of its target of selling 15,000 copies and had become too expensive to justify continuing with the venture.

The Welshman did leave one legacy. The Geoff Charles Collection in Aberystwyth has a better north-south balance and more pictures of heavy industry than would have been the case without its short-lived existence.

An unexpected warning from road workers in Pontardawe, near Swansea, 1951

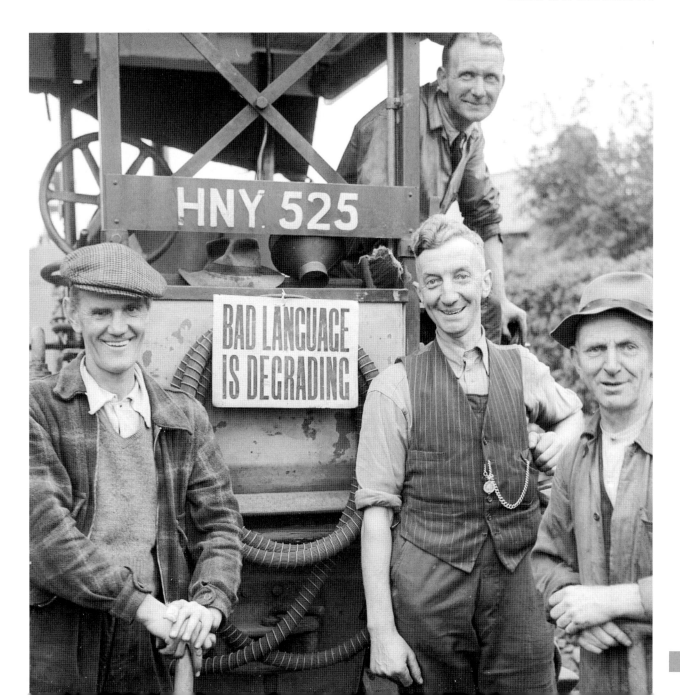

Cornelius Jones, road worker, chats with Colm, son of Dylan Thomas, Laugharne, 1955

Road workers or 'linesmen' at lunch, Bodegroes, near Pwllheli, 1958

Lettice Rees was described as queen of the female cockle gatherers of Llansaint, near Kidwelly, who used donkeys for transport. Aged 74 in 1962, she had been doing the work for 62 years. In her younger days she sold the cockles from door to door but now she took them for processing at a factory in Penclawdd

The Raven tinworks in
Glanaman, which once
employed six hundred
people, were being
demolished in 1949.
Two nightwatchmen,
Phil Phillips and D.H.
Hughes, were the only
ones left on the payroll

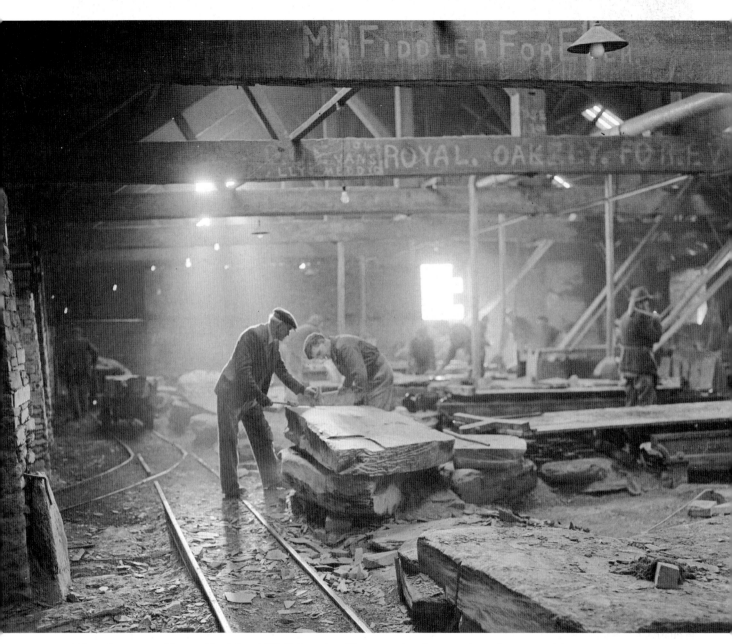

Y Foty slate quarry, Blaenau Ffestiniog, 1950. *Y Cymro* headline states that dust was the main enemy of the quarrymen

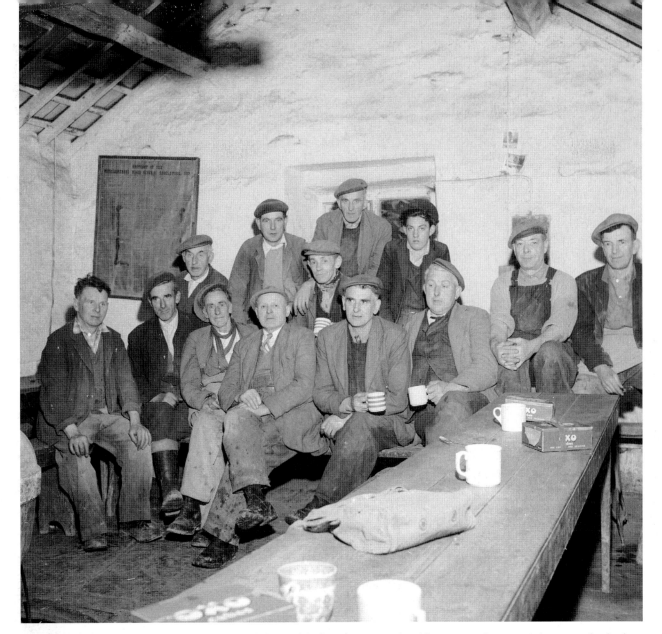

Y Foty quarrymen take a break in their caban (cabin) a week before the quarry closed in 1962. Y caban was an important institution in quarrying communities, a forum for political, religious and cultural discussions that produced writers and poets and generated a unique humour in adversity

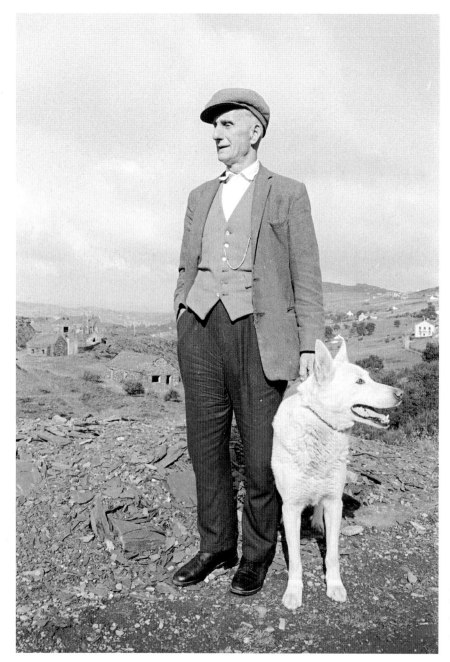

One man and his dog is all that's left.
William Williams at Dinorwig Quarry
where he used to work. The quarry
closed in 1969 with the loss of 350 jobs

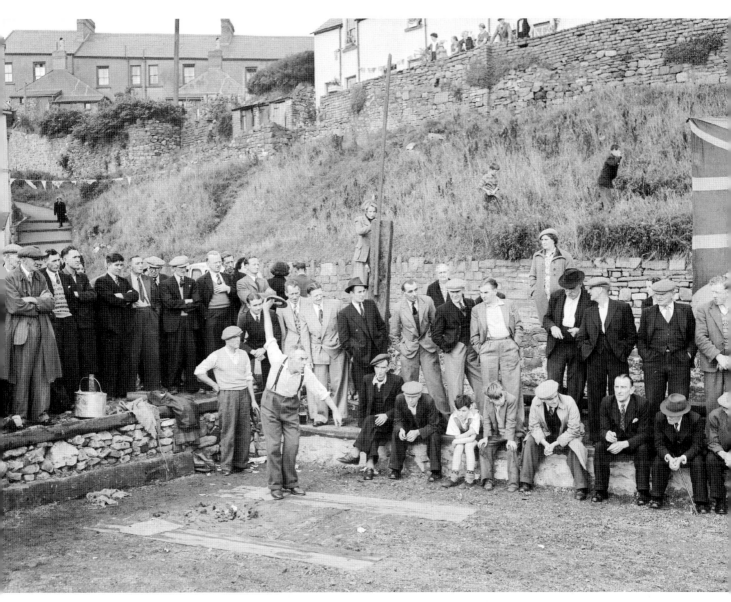

The ancient game of quoits was enjoying a revival among industrial workers in Merthyr Tydfil in the early 1950s

Inspecting the roof at Clogau gold mine in Bontddu, near Dolgellau, in 1960, when it was the only site producing gold in the UK

Richie Thomas, better known as one of Wales's foremost tenors, in his day job at Penmachno woollen mill in 1952

Schoolchildren walk alongside *The Countess*, the engine pulling the train through Welshpool on the Welshpool and Llanfair Caereinion Light Railway in 1950

'Coracles have been here for two thousand years. But unless the system changes there will be no coracle here or anywhere else soon. There will only be the river and the fish – and the River Board.' *Y Cymro* takes a dim view of regulations governing the use of coracles on the River Teifi in 1952. There were only four coracles operating at Llechryd, including the one pictured with its owner, 68-year-old John Jenkins

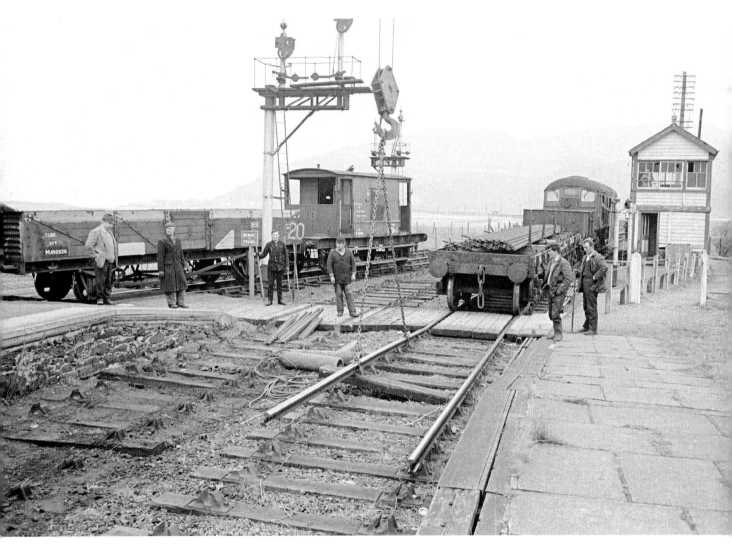

Workmen remove the rails at Morfa Mawddach after the closure of the railway line between Ruabon and Barmouth, 1969

The last train arrives in Caernarfon after the line from Bangor closed in 1972

Hufenfa Meirion, a cooperative creamery in Rhydymain between Bala and Dolgellau, was one of the success stories of rural Wales. Set up by local farmers in 1939, by 1954 it employed sixty people and new houses were being built for the workforce. Geoff Charles had probably consulted his railway timetable before he took this photograph, just as the train chugged its way through the valley, transforming the scene. The railway and the creamery are long closed

Moving to Bangor

Although Geoff Charles's name will always be linked with *Y Cymro*, it was not until 1958 that he became a full-time employee of the paper. In November that year the family moved from their Oswestry home to a house on Glanrafon Hill in Bangor, a move that had been suggested by John Roberts Williams. From then on Geoff did not have to concern himself with wedding photographs in Oswestry; there was no more arguing with fellow photographers over which film or camera they should use.

The previous year *Y Cymro* had published a supplement celebrating its twenty-fifth anniversary. It's significant that it contains only one of Geoff's pictures – the famous one of Carneddog and his wife Catrin about to leave their mountain home. The other pictures in the magazine were taken by Ted Brown, Robin Griffith and Ron Davies.

After his move to Bangor Geoff worked largely from home, where he had set up a darkroom with shelves for his negatives, and could also use the company's offices in Caernarfon and Bangor. Geoff was in his element: 'From then on I was free to travel with reporters to every part of Wales, taking the best pictures I could find. What could be better!'

The change in his work pattern is reflected in his archive in Aberystwyth. Not only is there a big increase in the volume of contact prints, but the subjects have a more national perspective. Ironically this was happening at a time when the golden age of *Y Cymro* was on the wane. The circulation dropped from 25,000 in 1956 to 20,500 1958; 15,700 in 1962 and around 7,000 in 1969. The company had seen a drop in its advertising revenue and reduced its investment in *Y Cymro*. But the main factor in the decline is illustrated in a picture by Geoff Charles of a street in Caernarfon with a television aerial on every roof. In a front page article in January 1959, John Roberts Williams wrote: 'When television arrived to rule the hearth some of the biggest and most colourful magazines in England failed to meet the challenge. The competition affected *Y Cymro* as well.'

Broadcasting challenged the printed word as a source of news and entertainment and bagged a slice of its advertising revenue. As Welsh-language programmes were being developed, some of the most talented staff members were attracted by the excitement and higher wages offered by the new medium. Prominent broadcasters like Meredydd Evans, T. Glynne Davies and Idris Roberts had served apprenticeships on *Y Cymro*. Two of Geoff Charles's fellow photographers, Robin Griffith and Ted Brown, joined the drift to the BBC. And after seventeen years in the editor's chair, John Roberts Williams left in 1962 to join Teledu Cymru, an ill-fated venture in the independent sector that folded after sixteen months. John Roberts Williams then had a successful career at the BBC.

Geoff Charles, the only one among the *Cymro*

photographers who had proven his ability to shoot and edit film, was the only one among them not to be tempted by the new medium. In his recorded reminiscences at the National Library, he discloses that he was once offered work as a cameraman by BBC Wales Head of Programmes, Hywel Davies, but turned it down. He would have had to buy his own equipment without any guarantee of how much work he would get, but above all, he said, he had too much loyalty to *Y Cymro*. It is also likely that the freedom he had to earn extra income from sources like the *Farmers Weekly* made it easier for him to resist the temptations of broadcasting. Had he left at that time it would also have cut short his unique documentary record of a pivotal event in Welsh history.

Hollywood star Ingrid Bergman filming
Inn of the Sixth Happiness in Beddgelert, 1958

Celebrations in Liverpool in 1965 to mark the centenary of the founding of the Welsh community in Patagonia. Members of the Urdd (Welsh youth movement) in period costumes were among those who took a short voyage along the Mersey to re-enact the departure of the *Mimosa* which carried the first settlers in 1865 (overleaf)

Tryweryn

In October 1955 Geoff Charles photographed two surveyors with drilling equipment investigating land near the village of Dolanog in Montgomeryshire. They were there on behalf of Liverpool Corporation who were looking for suitable sites for a reservoir to supply water for the city. Among the farmhouses that would be flooded was Dolwar Fach, home of leading Welsh hymn-writer Ann Griffiths. Those photographs were Geoff's first involvement with a saga that would keep him occupied periodically over the next ten years.

Some people in Wales sensed a conspiracy when Liverpool switched their attention from Dolanog to Cwm Tryweryn and the village of Capel Celyn near Bala. Was the threat to flood Dolwar Fach a ploy so that the change of target might be greeted with relief?

What happened next has been well documented and is still a source of resentment after fifty years. Liverpool Corporation had not consulted anyone in Wales before proceeding with their scheme. They instigated a private member's bill to get parliamentary approval. Not a single Welsh MP voted for the Bill but the Conservative Government whipped their members to support it and the Welsh members were easily outnumbered. All protests were ignored, including incidents of sabotage at the construction site.

'I was there from the very beginning and it was heartbreaking,' said Geoff. He photographed all key events in this David-and-Goliath story: the day the villagers took their protest to Liverpool and met nothing but contempt; farm auctions, demolition of the chapel, last day at the school, families leaving home for the last time. Although the fight was lost, Geoff thoroughly enjoyed the official opening in October 1965. Protesters drowned out the speeches and cut wires from the microphones, blocked the cars of VIPs and forced the ceremony to be cut short. 'It was a wonderful day – nothing too vicious but everyone showing their feelings.'

As a photojournalist he had become totally committed to the villagers' cause. He shared their anguish and supported them by supplying photographs for a pamphlet that the Defence Committee sent to all of Wales's MPs.

Tryweryn highlighted the political impotence of Wales at that time, and played its part in the increased national consciousness that led to devolution and the birth of the Welsh Assembly. More than fifty years after the opening of the dam the slogan 'Cofiwch Dryweryn' [Remember Tryweryn] is gaining momentum and Geoff Charles's poignant photographs have played an important role in ensuring that the story is not forgotten.

Calm before the storm: children at play in Capel Celyn in 1957

The last communal shearing day, an annual get-together that
had been a feature of life in the valley for generations

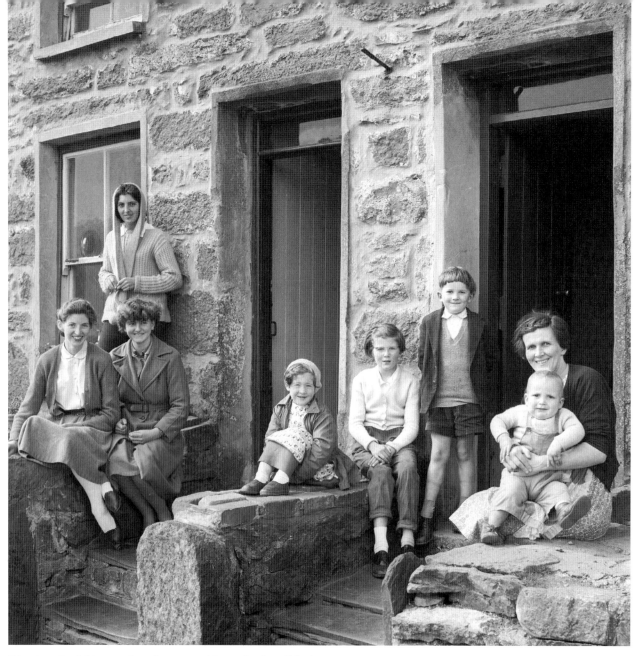

Friends and neighbours whose homes would soon be demolished

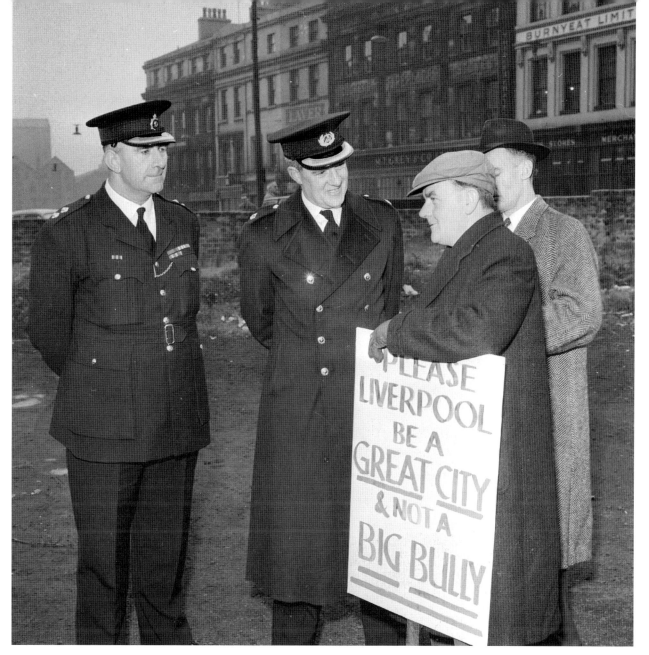

The Rev. Gerallt Jones pleads Tryweryn's case with Liverpool police when the villagers took their protest to the city

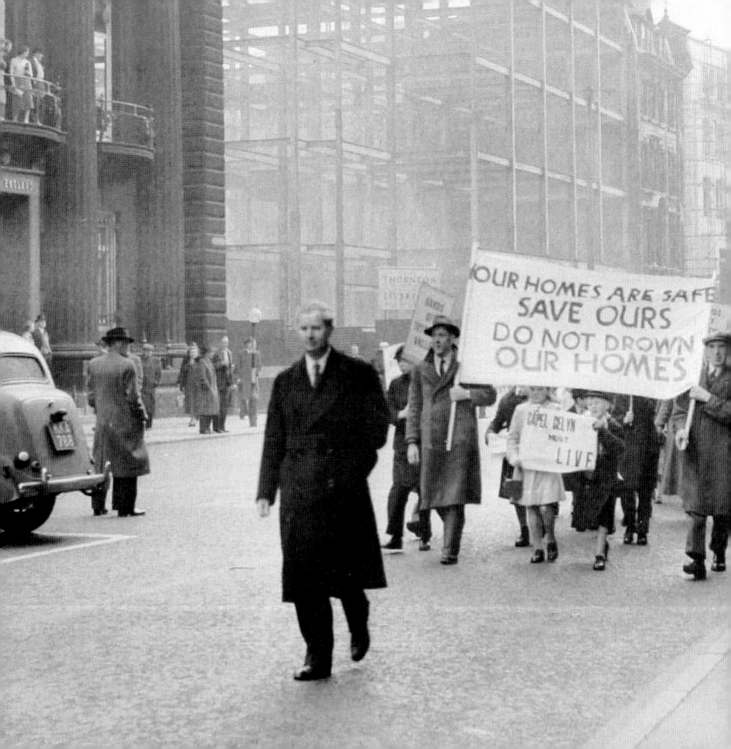

The villagers march through Liverpool,
led by Gwynfor Evans, Plaid Cymru
president and future MP

Policemen keep watch as worshippers arrive for the last service in the chapel at Capel Celyn, during which the chapel was deconsecrated

Deiniol Prysor Jones sits where the pulpit used to be in the half-demolished chapel

Pupils and their teacher, Martha Roberts, on the last day of the village school

The mood is captured on Aeron Prysor Jones's sombre face

John William and Mabel Evans close the door of their home, Garnedd Lwyd, for the last time

The struggle is over for the families who lived at Cae Fadog and Gelli, two of the sixteen farms abandoned

The whole village becomes a construction site

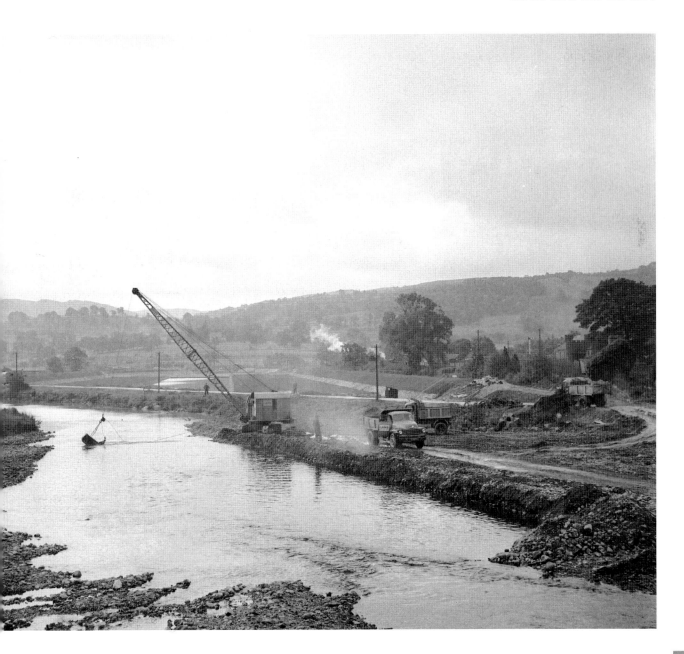

Guests for the official opening of
the reservoir in 1965 faced a hostile
crowd who forced the ceremony to be
abandoned

Eisteddfod

At the National Eisteddfod in Lampeter in 1984, Geoff was inducted into the Gorsedd of Bards under the bardic name 'Sieffre o Brymbo'. It was the climax of his long involvement with his country's leading cultural festival. Although he was a familiar sight at the National Eisteddfod for many years, he never tried to draw attention to himself, preferring to merge into the background. John Roberts, north Wales organiser of the Eisteddfod from 1959 to 1979, told me in 2005:

> I don't have many specific memories of Geoff, I just remember him doing his job so quietly without fuss. He went around without anybody noticing that he was there. He was not satisfied with taking the obvious pictures, but kept an eye for the different or unexpected angle. He knew precisely what the procedure was and how the Eisteddfod worked, and that made my job very easy. I had to deal with some very different photographers – I remember one of them asking me on the day of the Chairing ceremony if that was the first time we'd given a Chair as the prize in that particular competition.

There was little awareness of any eisteddfod, national or otherwise, during his childhood in Brymbo. I've already mentioned the reference to the Mold event which gave him the opportunity to travel with the driver on a train. He did win a prize at an eisteddfod in Grove Park County School – not for anything musical or literary but for making a model of a bus.

By the time he retired in 1975 Geoff had a collection of Y Wasg [Press] Eisteddfod passes stretching back to the Machynlleth event in 1937. With one or two gaps when the Second World War disrupted the festival, he had taken pictures at every National Eisteddfod up until the Cricieth one in 1975, the year of his retirement. For some years even after that he took his camera to the Eisteddfod to take photographs for his own enjoyment.

His first National Eisteddfod in Machynlleth was a memorable one for Geoff. Local landowner Lord Londonderry had offered land for the Eisteddfod's use and was invited to preside over one of the week's concerts. But he happened to be head of the Air Ministry who had built the controversial RAF base at Penyberth in Llŷn. Three Welshmen who would normally have been at the Eisteddfod were in Wormwood Scrubs prison for setting fire to the 'Bombing School'. Six would-be adjudicators resigned in protest, the Lord refused to attend the concert, and his seat was left empty.

But Geoff had another reason to remember his first National Eisteddfod. On the way to Machynlleth he had left his tripod on a train, never to be found

again – a most untypical lapse of concentration. In those days the stage was so badly lit and flash so unreliable that a tripod was essential. Even then the only way to be sure of getting a decent picture of the winners of the Chair and Crown was to take the winning poets out into the open air to be photographed.

By the Denbigh Eisteddfod in 1939, Geoff had acquired a new Leica camera with a faster lens which could cope with lower light levels. Even then he had to hold the camera steady at maximum aperture for quarter-second exposures to secure pictures of the main ceremonies. But he was unlucky again as there were no poets to be photographed. The adjudicators had decided that no competitor had reached the required standard in either competition, the only occasion in the twentieth century when no-one was deemed worthy of the Chair or the Crown.

Geoff, who was always smart and orderly in everything that he did, was critical of what he perceived as a lack of dignity in the Gorsedd in those days. 'A shabby collection of men,' he said once after seeing the druids smoking and walking in a slip-shod manner down a street. Cynan, the most influential personality of the century in the Eisteddfod, agreed that it needed reforming. And Geoff took pride in having played a small part in the modernisation that occurred at the end of the 1940s.

Cynan, Recorder of the Gorsedd at the time, was in London with Geoff and John Roberts Williams to record the commentary for *The Heritage* and other films. When the three were having a meal at Cynan's favourite restaurant in Soho, he asked Geoff his opinion of the lighting on the stage during the main ceremonies.

The biggest change was to install a curtain across the stage, with a substantial proscenium between the audience and the curtain. Gorsedd members on the stage would be hidden until the curtain rose, exposing the scene with the Chair as the centrepiece. The problem then for Geoff and his fellow photographers was that they were now at least forty feet away from the winning poet in his or her Chair. But later, with his Nikon camera and a 200 mm lens, he used to say that he could, if necessary, show details of the skills of the winner's dentist! And the quarter-second exposure that used to be necessary had been reduced to a hundredth of a second.

The first full week of August – Eisteddfod week – was always the highlight of the year for *Y Cymro* staff. For photographers it was also by far the busiest, especially when the Eisteddfod was in the south and far from base. When the Eisteddfod was in north or mid Wales, the films would be driven to Oswestry for processing, but a southern Eisteddfod usually involved setting up an improvised darkroom somewhere in the vicinity. In Aberdare in 1956 the company had got hold of an old ambulance that used to belong to the American Army and installed the necessary equipment in the back. In Ebbw Vale

two years later, the darkroom was in the cellar of Geoff's lodgings in Aberbeeg, where he processed pictures of Paul Robeson singing at the opening concert.

Through years of practice Geoff had developed a routine that he followed instinctively in the quest for the best picture. He had come to recognise the gestures and behaviour patterns of winning poets, which remained remarkably consistent whoever the winner was. He described this skill in a catalogue for his exhibition in Lampeter in 1984:

> [With the development of longer, faster lenses] I could now look for the different picture – the unsteady Crown (they never seem to fit) and the hesitant, nervous hand trying to straighten it. It's worth seeing the women who are crowned: they worry that the headgear is seen tilting precariously over one eye.

> As the all-important person in the Chair familiarises with the drama that put him or her where he or she is and begins to enjoy himself or herself, you get myriad pictures of the face reflecting the inner feelings.

One of the people who had presented Geoff's name for honour by the Gorsedd on his retirement was D. Llion Griffiths who had been editor of *Y Cymro* since 1966. He said, 'Eisteddfodau and agricultural shows were the most important aspects of Geoff's work – not only the national ones but smaller ones as well. And he always kept a detailed record of everything, making sure that it would all be accessible to future generations.'

Famous American singer Paul Robeson was a special guest at 'y gymanfa ganu' during the National Eisteddfod in Ebbw Vale in 1960. The previous year he had been invited to the Miners' Eisteddfod in Porthcawl but the US authorities had withdrawn his passport for political reasons. He got a rousing reception in Ebbw Vale

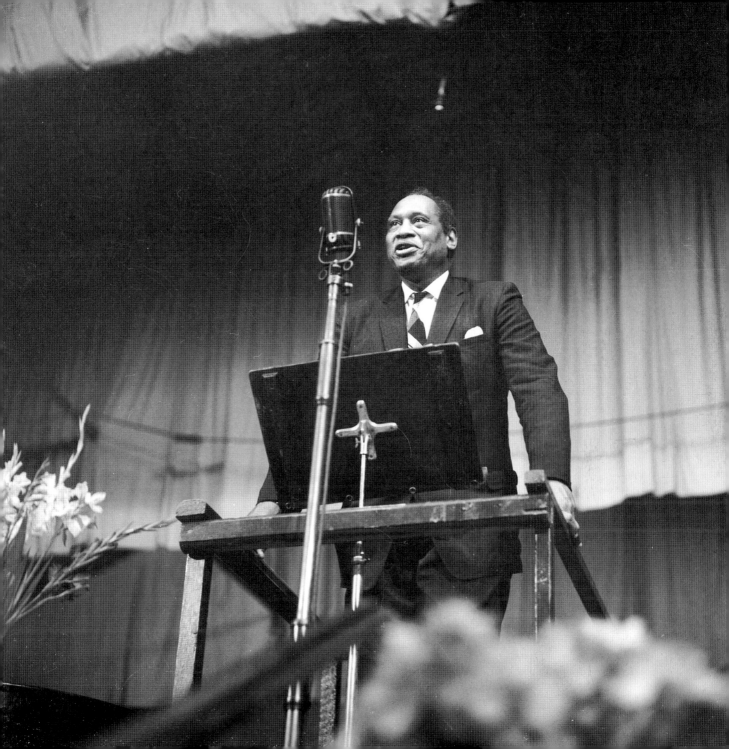

Only in a coal mining area would splicing an iron rope be included in National Eisteddfod competitions. This team competing in Aberdare in 1956 are from the Great Mountain Colliery, Tumble

Poet Alan Llwyd won both the Chair and the Crown at the Ruthin National Eisteddfod in 1973. Through long experience, Geoff was always on standby for the moment when the crowned bard would check that the headgear would not tilt or even fall off

Eleven-month-old Kevin Jones dwarfed by instruments of the Corris Brass Band with whom his father competed in Bala in 1965

The Rhosllannerchrugog National Eisteddfod in 1945 was a historic occasion because of an announcement from the stage that the Second World War had ended. The audience broke into a spontaneous rendering of the peace hymn 'Cyfamod hedd, Cyfamod Cadarn Duw', unaware as yet that it was the dropping of the atom bomb on Japan that had ended the fighting

Visitors arrive at the first International Eisteddfod in Llangollen in 1947,
giving Geoff the added satisfaction of photographing a train

Fairly or otherwise, some Eisteddfodau are remembered for challenges
encountered, including the weather. This was Ruthin in 1973 when the
River Clwyd burst its banks, turning the Maes into a lake

Geoff was the first photographer to utilise the Llangollen Canal to convey the colour of the eisteddfod
– even in black and white. These dancers at the first event are from Spain

Before its move to a permanent site in Llanelwedd, the travelling Royal Welsh Show, like the
National Eisteddfod, was at the mercy of the weather. This was the scene in Machynlleth in 1954

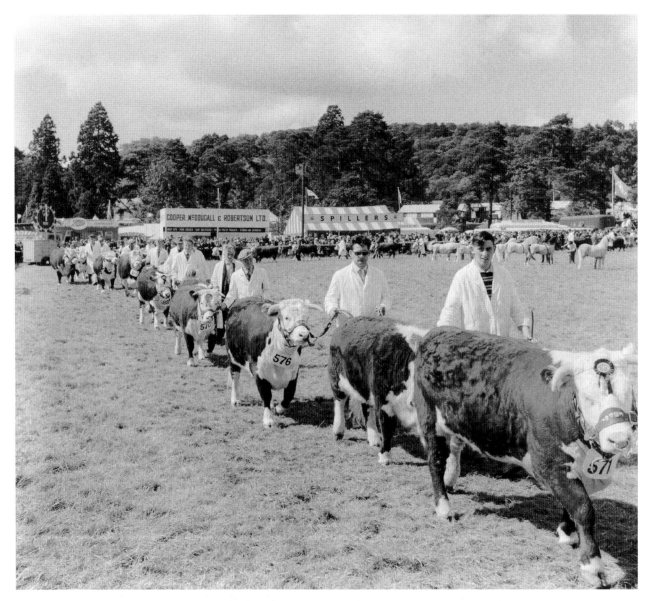

The weather was much kinder for the first 'Royal Welsh' at its new home in 1963

Fire and protests

To Geoff the Britannia Bridge over the Menai Strait was one of the sacred places of Wales. His childhood fascination with trains never waned and, because his mother's grandfather had once been station master at Menai Bridge, he had inherited a folk memory of Stephenson's tubular bridge that went back to its opening. Working in his darkroom at home in Bangor on a Saturday evening in 1970, he had the shock of his life when he heard on the radio that the bridge was on fire. 'I could not believe it,' he said. 'How could something made of iron be on fire?'

But with his photographer's instinct he was soon heading out in his car and saw that the bridge was indeed ablaze. Even then it was hard to believe that a structure he had cherished so much was being utterly destroyed. 'What went through my mind was "What would my mother think of this?".'

Once again he had been in the right place at the right time and, although it was not a sight he relished, his professional instinct soon took over. Getting the exposure right was no easy task, with burning debris streaming down against a pitch-black background. He set ten-second exposures at maximum aperture, wedging the camera to hold it steady without a tripod. He was pleased with the dramatic photographs but sickened by what they depicted.

The late 1960s and early 1970s were a turbulent period in Wales. Hot on the heels of the Tryweryn struggle the country became divided over the plan to hold a ceremony in Caernarfon to invest Prince Charles as Prince of Wales. The polarisation became so intense that it was difficult for any newspaper to sit on the fence and, as the pro-Investiture propaganda machine gathered pace, *Y Cymro* found itself siding more and more with those who saw the whole thing as a charade and a national affront. The older generation, including some of Geoff's contemporaries who had been active contributors to *Y Cymro*, disagreed with this new line and many of them severed their connection with the paper. Geoff, coming from a far less 'Welsh' background, never seemed to have any difficulty with the paper's stance. I never heard him express any party-political views apart from following the family loyalty to the Liberals in his youth and campaigning for Clement Davies to retain his seat during his time in Montgomeryshire. During the Investiture period he seemed totally relaxed taking pictures of royalty and protestors with the same professional detachment.

When it came to language activists, however, he made no pretence at neutrality. He was an unapologetic supporter of the campaigners right from the first mass protest by Cymdeithas yr Iaith Gymraeg [Welsh Language Society] in Aberystwyth in February 1963 to demand official status for the Welsh language. The day started with students sticking posters on the town's post office and developed into a spontaneous sit-down that blocked the main road

south at Pont Trefechan. The aggressive attitude of some onlookers had a deep effect on Geoff.

'I remember one tall, smart man who looked like a nobleman from a bygone age urging motorists to drive right through the protesters. A woman from London who was protesting was struck down, apparently out cold, and another woman was shouting at her, "Serve you right, you silly fool". I knew in my heart – something big is happening here. The effect of this will be felt in Wales for a very long time.'

Geoff never lost his admiration for the young activists and I accompanied him on other protests. We followed a campaign, unsuccessful as it turned out, to save the village school at Bryncroes in Llŷn from closure. His pictures of these campaigns are as well known as his Tryweryn photographs.

The Brittania bridge ablaze, May 1970

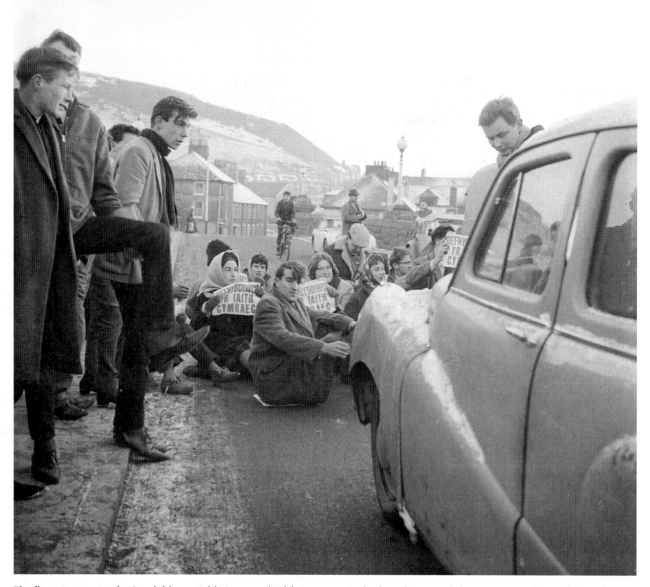

The first mass protest by Cymdeithas yr Iaith Gymraeg (Welsh Language Society) at Aberystwyth in 1963. Campaigners demanding official status for the language blocked Pont Trefechan, a bridge on the main road leading south. This provoked a hostile reaction from some onlookers and a woman protester was thrown to the ground. The day's events left a lasting impression on Geoff Charles

Factory owner W. Brewer-Spinks has his car blocked by protesters in 1965 after he sacked two men who refused to obey an order banning them from speaking Welsh in their workplace at Tanygrisiau in Merionethshire. After widespread opposition, the ban was withdrawn and the two workers were readmitted two weeks later

A rally at Bryncroes on the Llŷn peninsula opposing Caernarfonshire County Council's decision to close the village school. Although the Bryncroes struggle was lost, it helped to spark decades of debate in Wales about the fate of small rural schools

In 1972 the Lord Chancellor, Lord Hailsham, provoked outrage in Wales when he made a speech to Conservatives in which he compared Welsh language activists to 'baboons of the IRA'. When he later visited the University College of North Wales, Bangor, to address magistrates, he faced a hostile crowd brandishing posters depicting him as a pig

Retirement

'Photographers never retire,' said Geoff's friend and fellow photographer Ron Davies. 'Taking pictures is in their blood and the only way to get rid of it is to drain all the blood out.'

There was no better example of that than Ron Davies himself. When I interviewed him in 2004 for my first book on Geoff Charles he was well into his eighties, had been in a wheelchair for over fifty years following an accident which required amputating his legs, and was still taking pictures with enthusiasm. Geoff 'retired' from his post with *Y Cymro* in 1975 but continued to work freelance, supplying pictures for the *Radio Times*, *Y Cymro*, the farming press, the Welsh Theatre Company, Gwynedd Archive Services, and anyone else who wanted his services. He also had more time to combine two of his lifelong passions: travelling on trains with his camera.

In November 1977 his wife Verlie was taken seriously ill when she and Geoff were visiting their daughter Susan in Lampeter. Susan's husband was a ship's captain with an oil company, sailing mainly from Milford Haven in Pembrokeshire. Geoff and Verlie decided to sell the family home in Bangor and go to live with Susan. As Verlie's health continued to deteriorate, they moved to live in sheltered accommodation with healthcare services in another part of Lampeter. Geoff became reacquainted with two colleagues from his *Cymro* days, Ron Davies and Ted Brown, who also lived in Cardiganshire at this time.

In January 1981 Verlie died. Geoff, alone and devastated, still enjoyed the company of neighbours who had made him feel so welcome. Although there were no longer any family ties to keep him in south-west Wales, he decided to stay. By then he had already donated his collection of 120,000 negatives to the National Library in Aberystwyth. North Wales Newspapers, the company he had served for most of his career, agreed that any copyright they may have held in the collection would be transferred to the library.

In June 1982 Geoff was invited by the National Library to lead a team of workers employed under the Manpower Services Commission for the specific task of cataloguing all the negatives in the archive. Library experts made contact prints of the complete collection and filed them with background notes prepared by Geoff himself. During the early stages of this work the library organised an exhibition of photographs taken by Geoff at the National Eisteddfod between 1939 and 1979, and a selection was shown when the Eisteddfod was held in his adopted town in 1984.

The collection was still growing at that stage and the photographs he kept taking in the 1980s are testimony to his dedication to his profession. He took his camera with him on train journeys to Lymington and Penzance and on a visit to Perth in Scotland with a group of farmers. He revisited his native Brymbo,

recording the changes it had seen with the decline of heavy industries. He would walk around Lampeter, documenting the preparations for the visit of the National Eisteddfod, new developments at the local university, and the building of a new cattle market.

Work on digitising and safeguarding the archive, the largest photographic collection at the National Library, continued for a long time after Geoff's involvement. He recorded several hours of biographical audio interviews with library staff which are safely preserved at the National Screen & Sound Archive of Wales in Aberystwyth. All aspects of work on the archive has benefited from the methodical and diligent way he kept notes and filed his negatives throughout his long career. 'Filing was Geoff's strength,' said colleague Robin Griffith. 'Ted Brown and I were as bad as each other in that respect. Once we had taken pictures we would forget about them. Not so with Geoff.'

In the 1990s library staff discovered that some of the negatives in Geoff's collection were deteriorating due to a chemical reaction that was causing the cellulose to decay. The images would have been destroyed in time but a technique was developed to save them. Many of the images have now been digitised.

Ann Griffiths, poet,
bardic name Ann o Lŷn, 1973

Sir Clough Williams-
Ellis, architect,
Plas Brondanw,
Llanfrothen, 1973

Myra Williams, watchmaker,
Amlwch, 1973

Sir John Hunt and Tenzing Norgay, Everest climbers' reunion, Pen-y-gwryd, 1973

Jonah Jones, sculptor, shares his workshop with Breton onion seller, Tremadog, 1962

Jack Price, customer and
donkey, Aberystwyth, 1952

Lord Bertrand Russell, philosopher, peace activist, with visitors at his Penrhyndeudraeth home during the Cuba crisis, 1962

T.E. Nicholas (left), poet, preacher and communist, and D.J. Williams, writer, teacher and patriot, at CND rally, Aberystwyth, 1961

R.S. Thomas, poet, 1967

Elin Hughes, aged 102, Rhiwlas,
near Bangor, 1958

Manffri Wood,
gamekeeper, Bala, 1952

Jim Jones, farmer, Nant-y-moch, Cardiganshire, 1956

Loss of sight

In January 1986, at Brunswick Chapel in Rhyl, Geoff Charles and Doris Esmor Thomas were married. They were cousins, Doris's mother being the sister of Geoff's father.

'I knew Uncle Geoff when I was a small child. He would often call to see us in Rhyl and it was with us that he stayed when the National Eisteddfod was in Rhyl,' said Doris's daughter Glenys Gruffydd. 'He was a very lonely man after he lost Verlie and would often call to see my widowed mother. In the end the two got married and Geoff moved to live in her home in Rhyl.'

But their time together was cut short. Soon after their marriage Doris's health deteriorated and Geoff rapidly lost his sight, the worst possible nightmare for a photographer. What started as glaucoma had led to sudden blindness. There was no way that either of them could care for the other. Doris moved to live with daughter Glenys and her family in Caernarfon. Geoff went into a home for the blind in Abergele, then to another one in Kinmel Bay near Rhyl, and finally to a nursing home in Gobowen near Oswestry.

'It was so unfair,' said his friend and colleague John Roberts Williams. 'Geoff, of all people, going blind, and me who never owned a camera retaining my eyesight.'

Before he lost his sight Geoff, with help from his brother Hugh, had started writing the story of their childhood in Brymbo and the central part that the railway played in their lives. The book was planned, says Geoff in the Introduction, as a retirement project for the brothers. John Roberts Williams had read the manuscript and showed it to Myrddin ap Dafydd of Gwasg Carreg Gwalch, who was his neighbour at the time. *The Golden Age of Brymbo Steam* was published in 1997, too late for Geoff to see it. His brother Hugh had left his home in Spain to spend time with Geoff while finishing the book. Geoff's son John corrected the proofs.

Two years previously the National Library had staged an exhibition of Geoff's photographs at their headquarters in Aberystwyth, and later at Bodelwyddan Castle near Rhyl. Geoff, totally blind and in a wheelchair, visited that exhibition where he was interviewed for S4C's news programme. The pictures he was unable to see were shown in the background. 'I can see every one of them in my mind,' he told the interviewer.

Geoff Charles died, aged 93, at the Meadowbank Nursing Home in Gobowen on 7 March 2002.

At his funeral in Shrewsbury, his son John spoke of Geoff as a storyteller above all else. This was the father who would entertain his small children with stories about the characters he had devised for the young readers of the *Montgomeryshire Express* all those years ago. This was the photojournalist who had recorded, throughout his long career, big and small events in the history of Wales. And in his

final illness he was entertaining some of his fellow patients in hospital with his reminiscences. John recalled:

We nearly lost him three years previously when he was ninety. Twice at that time he was taken to Glan Clwyd Hospital in Bodelwyddan. He was in the same ward both times, with about six other men. Some of these men had had major surgery and were in a very bad state, and unable to sleep at night. Because my father was blind he didn't know the difference between night and day, and if there was anybody else awake he would start talking to them. All this was happening the first time he was in the ward.

When he went back to the hospital the second time I went with him in the ambulance and put him to bed. The same patients were still there, and to my surprise there was a bit of excitement in the ward when they saw my father arriving. "Geoff is back," they said. They were so glad to see him again because of the stories he'd been telling them the first time. These men were a generation or two younger than him, but they were delighted to hear about the places, the events and all the things he had seen.

I mentioned that memory in the funeral service. He knew everybody, he could talk about anything, important or trivial, that he had recorded over more than sixty years. The Gresford Disaster, National Eisteddfodau, the Tryweryn saga, Prince Charles's investiture – he was there and had seen it all. And there he was, at the age of ninety, with all these stories to sustain other people through the darkness. To a journalist and a photographer, you cannot have a happier epitaph than that.

Geoff at an exhibition of his photographs at the
National Eisteddfod in Lampeter, 1984

Geoff cataloguing his images at the National Library assisted by Robin Hughes, 1984

Sources

Newspapers and periodicals
Border Counties Advertizer
Country Quest
Montgomeryshire Express
Welsh Farm News
Y Cymro

Books
Charles, Geoff and Hugh, *The Golden Age of Brymbo Steam* (Gwasg Carreg Gwalch, 1997).
Elis, Nan & Ffrancon, Gwenno (eds), *Llais Cenedl: Cyfrol Deyrnged John Roberts Williams* (Gwasg Gwynedd, 2008).
Jones, Robin, *Cofio'r Cymro* (Y Lolfa, 2007).
Jones, William D., *Wales in America: Scranton and the Welsh 1860–1920* (University of Wales Press / University of Scranton Press, 1993).

Thomas, Robbie, *The Advertizer Family: A history of North Wales Newspapers Limited* (North Wales Newspapers, 1988).
Williams, E. Namora, *Carneddog a'i Deulu* (Gwasg Gee, 1985).

Radio and television programmes
Beti a'i Phobol, Radio Cymru
Camera'r Cymro, HTV / S4C
Croma, Cwmni Da / S4C

National Library of Wales
Recorded interviews with Geoff Charles at the Screen & Sound Archive
Background notes by Geoff Charles to accompany the 'Geoff Charles Collection'

Also from Y Lolfa:

WALES AND THE SEA

10,000 YEARS OF WELSH MARITIME HISTORY

EDITED BY MARK REDKNAP, SIAN REES AND ALAN ABERG

COMISIWN BRENHINOL HENEBION CYMRU
ROYAL COMMISSION ON THE ANCIENT AND HISTORICAL MONUMENTS OF WALES

y olfa

£24.99

Ask for a print quote!
www.ylolfa.com